T0278080

CHURCHES OF DERBYSHIRE

DAVID PAUL

AMBERLEY

This edition first published 2022

Amberley Publishing
The Hill, Stroud
Gloucestershire GL5 4EP

www.amberley-books.com

Copyright © David Paul, 2022

The right of David Paul to be identified as the Author
of this work has been asserted in accordance with the
Copyrights, Designs and Patents Act 1988.

All rights reserved. No part of this book may be reprinted
or reproduced or utilised in any form or by any electronic,
mechanical or other means, now known or hereafter invented, including
photocopying and recording, or in any information
storage or retrieval system, without the permission in writing
from the Publishers.

British Library Cataloguing in Publication Data.
A catalogue record for this book is available from the British Library.

ISBN 978 1 3981 0420 4 (print)
ISBN 978 1 3981 0421 1 (ebook)

Typesetting by SJmagic DESIGN SERVICES, India.
Printed in Great Britain.

CONTENTS

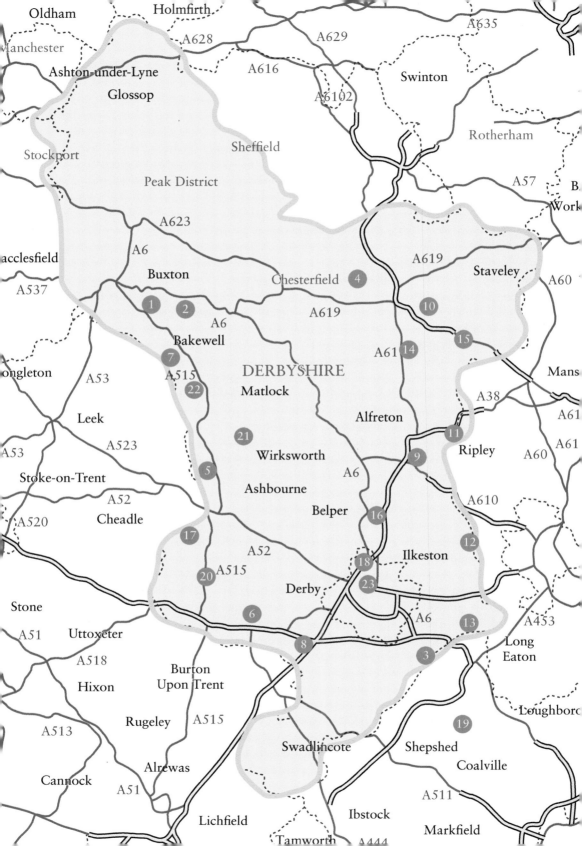

INTRODUCTION

It doesn't take a massive leap of imagination to understand and appreciate just why architects, estate owners and local country folk were able to gain inspiration to design and build so many iconic churches of beauty and graceful proportions when the backdrop is the unspoilt and tranquil rolling countryside of Derbyshire; indeed, Derbyshire can boast a plethora of ancient and historically significant churches.

Several different styles of architecture can be seen in the twenty-three Grade I listed churches featured in the text, the earliest dating from the Saxon and Norman period. However, during the twelfth century the old Norman style of architecture was gradually being replaced in church architecture by the Gothic style of architecture, which had its origins in north-west France. English Gothic architecture flourished between around 1180 and 1520. The three predominant styles included: Early English Gothic, dating from 1180 to 1250; Decorated Gothic, which was fashionable between 1250 and 1350; and Perpendicular Gothic, dating from 1350 to 1520. Early English Gothic is characterised by pointed arches or lancets. In addition to using pointed arches in wide-span arches such as the nave arcade, lancet design was used for doors and, more often, stained-glass windows. Decorated Gothic is characterised above all by the tracery on the stained-glass windows. Design innovations enabled increasingly elaborate windows to appear, separated by narrowly spaced parallel mullions. Perpendicular Gothic is characterised by a predominance of vertical lines, which is most noticeable in the stone tracery of the windows. This is demonstrated to its best effect in the design of enlarged windows, utilising slimmer stone mullions than was possible in earlier periods, thus giving greater flexibility for stained-glass craftsmen. Also, because of various difficulties that often arose in building during those tumultuous times, many of the churches described incorporate a number of different architectural styles, indicating that the building took many years to evolve and complete. Similarly, it was not unheard of for a church benefactor to have the church rebuilt or substantially modified to conform to contemporary ecclesiastical fashion.

The book does not purport, in any way, to be an academic text, but is aimed at the general reader.

David Paul

1. ST JOHN THE BAPTIST'S, TIDESWELL

The Domesday Book reveals that there was a priest in the village of Tideswell as early as 1193, but it was not until the episcopate of Roger de Weseham, 1245–56, that Tideswell was constituted as a separate parish. At that time the original Norman chapel was still in existence and that, in all probability, it was replaced by the present church. It is thought that the church of St John the Baptist, Tideswell, was started in or around 1320. Much of the building, including the nave, aisles and transepts follows the Late Gothic style; however, construction was not completed until early in the fifteenth century, and the chancel and pinnacled tower, which were added towards the end of the century, were built in a Perpendicular style. One reason forwarded for the particularly lengthy period of construction and change of architectural style lies in the fact that, for much of that time, the region was blighted with the curse of the Black Death and that, perhaps because of the ravages inflicted by the plague and the resulting shortages of skilled craftsmen, architects began to favour a less complex form of design, thus, to some extent, accounting for the transition from the Gothic style of architecture to the Perpendicular style.

The church, often called the 'Cathedral of the Peak' because of its graceful proportions and size, has a nave that is in excess of 82 feet in length. The width of the church, including the side aisles, is over 56 feet and of the chancel is unusually large, being 62 feet 6 inches in length.

At the time of building, in addition to the high altar in the chancel, there were no less than four other altars. Of particular note is the De Bower chapel, which

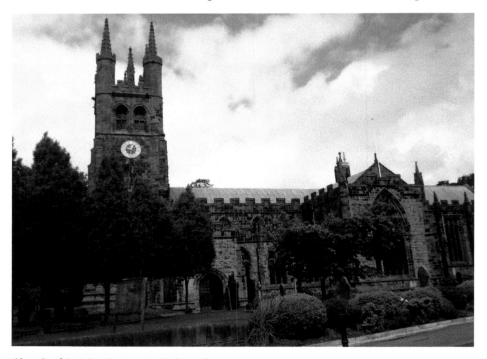

Church of St John the Baptist, Tideswell.

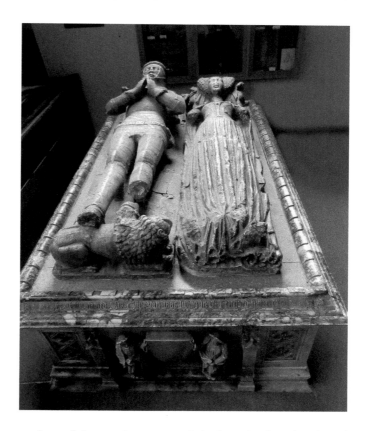

The tomb of
Sir Thurstan and Lady
Margaret de Bower.

is located in the innermost bay of the south transept. It is thought that the chapel holds the recumbent alabaster figures of Sir Thurstan de Bower and his wife Margaret, although this is not a universally held view, as there are no records of a knight known as Thurstan de Bower. Speculation as to who are represented by the effigies ranges from members of the Lytton, Stafford or Foljambe family members; but again, this is just speculation.

Adjoining the De Bower chapel on the south aisle is the Litton chapel, commemorating the family who took their name from that manor. Since 1928 the Gabriel Bell has rested on the floor of the Lytton chapel. It is a commonly held belief that the bell is as old as the church itself. Although there is no evidence now of an altar being present, the chapel on the opposite transept corresponding with the Lytton chapel was at one time appropriated by the manor of Wheston, as it is in this part of the church that seats were claimed for that particular hamlet. The lady chapel was in the north transept, and it was here that the altar of St Mary stood.

The altar tomb of a local knight and landowner, Sir Sampson Meverill, can be seen in the centre of the chancel and, within the altar rails on the north side of the chancel, is the tomb of John Foljambe. It is thought that from the time of their first settlement in the parish, soon after the Conquest, the Foljambe family were buried in the chancel of the church. Several generations of the family were buried there until the extinction of the male line of the elder branch by the death of Roger

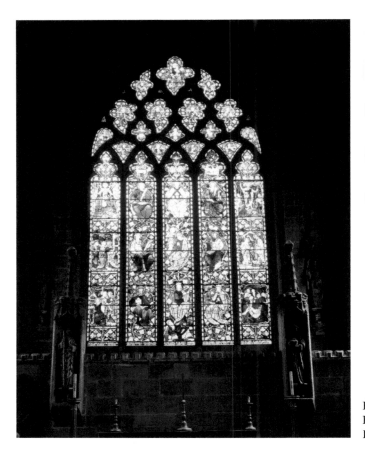

East window by
Heaton, Butler and
Bayne.

Foljambe in 1448. Another unusual feature relating to the chancel is the stone
reredos, which extends across the whole width of the east end, and has a door on
the north side leading into the sacristy.

To the west of the Foljambe tomb is a brass commemorating Bishop Robert
Pursglove. Pursglove was born in Tideswell in 1504 and founded the local
grammar school in 1560. Earlier, in 1538, he was appointed suffragan Bishop
of Hull, but was deprived of the office in 1559 for refusing to take the Oath of
Supremacy. He returned to Tideswell and died there in 1579.

The old stone chapel, or oratory, was probably erected before the reign of King
John. There was much local superstition associated with the oratory – reports
suggested that unseen choristers could sometimes be heard singing very sweetly as
they passed in procession along the vaulted passages of the chapel to the chancel
of the church and, whenever this ceremony occurred, it was said to presage the
approaching death of an important personage in the town. During its demolition
in 1812 many human bones were found when the chapel was un-floored, giving
credence to the local superstition.

In 1873 John Dando Sedding began a major restoration of the church, which
involved replacing and re-leading the oak roof. The church was reopened on
30 September 1875. Some restoration work continued until 1905.

Above: The tomb of
Sir Sampson Meverill.

Right: One of the many
exquisite carvings by local
master woodcarver Advent
Hunstone.

The east window, dating from 1875, is by Heaton, Butler and Bayne and depicts the Tree of Jesse. The west window, dating from 1907, is by Hardman and Powell.

The church's main organ, built by Forster and Andrews, dates from 1895 and can be seen in the north transept.

Many examples of the work of master woodcarver Advent Hunstone, a local man, are displayed in the church, including the eagle lectern, the choir stalls and screens and the vicar's chair.

Location: **SK17 8NU**

2. ALL SAINTS', YOULGREAVE

During the time of Edward the Confessor a man named Colle was one of the two Saxon owners of the manor of Youlgreave (Giolgrave; Youlgrave), and it was his grandson, Robert, who gave the church of Youlgreave, with its chapels, lands, tithes, and all things pertaining, to the Abbey of St Mary of Leicester. The abbey was founded in 1143.

It is known that there was a Saxon church on this site as early as the eighth century. The present church, however, was built sometime during the twelfth century, with the first written record being dated 1155.

Dedicated to All Saints, the church of Youlgreave has a chancel, nave, north and south aisles, south porch, and an embattled tower at the west end. A number of different architectural styles are evident in the church. The Norman architecture remaining would suggest that the church was built sometime between 1150 and 1170 by Robert Colle. The nave is the oldest surviving part of the church, displaying the typically thick circular Norman pillars, which support the chamfered arches that separate the nave from the side aisles. However, the arches springing from the pillars on the south side being circular are undoubtedly of the Norman period, while those on the north side are pointed suggesting that they, together with the chancel, were added sometime in the fourteenth century. The imposing bell tower dates from the Perpendicular style of the fifteenth century and has an embattled summit with eight-crested crocketed pinnacles. The tower also has a projecting embattled stair turret at the south-east angle, which rises to the first two stages of the tower.

Near to the porch at the south of the church are the steps of the old churchyard cross together with a large basement stone, upon which is the metal plate of a sundial. The plate bears an inscription: 'Mr Joseph Smedley, Churchwarden, 1757. Sam Ashton, Tideswell.'

At one point Youlgreave is thought to have had three altars: two side altars at the east ends of the aisles, and the high altar in the chancel. There was also in the north-east angle of this aisle and behind the pier of the chancel arch a 'squint', through which there was a clear view of the high altar – of great assistance to the organist when directing the choir.

The late fifteenth-century alabaster reredos in the north aisle is a memorial to Robert Gilbert and his wife Joan. The tomb to Roger Rooe of Alport and his wife can also be seen in the north aisle. He is depicted facing his wife and their eight children are shown on a frieze below. There are many other memorials in the

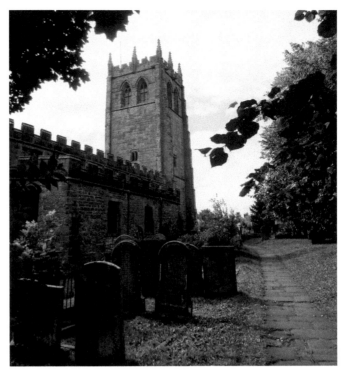

Right: All Saints' parish church, Youlgreave.

Below: Youlgreave nave c. 1906.

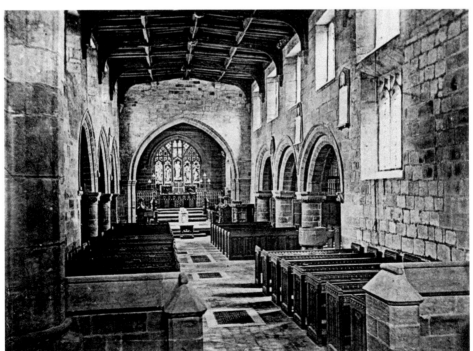

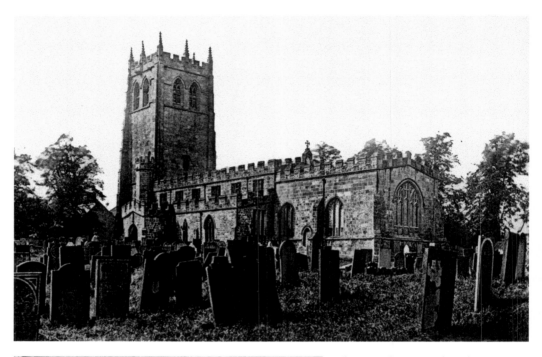

Above: Early image of Youlgreave parish church.

Left: Priest's entrance to the parish church of All Saints, Youlgreave.

church, including two well-preserved medieval tombs in the chancel. The first is thought to be that of Sir John Rossington and dates from the thirteenth century, while the second dates from the fifteenth century and is an effigy of Thomas Cockayne, who died as a result of having fought a duel in which he took a fatal injury. The small alabaster altar tomb was restored by members of the family. There is also in the north aisle a memorial window to Captain Rennie Crompton Waterhouse, who died at Gallipoli. The window contains fragments of glass brought from the ruined cathedral of St Martin's at Ypres.

The great painted-glass east window showing Christ and the four evangelists was designed by the Pre-Raphaelite master Edward Burne-Jones and made by the William Morris Company. It is thought that the four angels in the upper lights are the work of William Morris.

The medieval character of the church was sensitively maintained when the architect Richard Norman Shaw restored and refurbished much of the church's fabric between 1869 and 1870. A new east window was installed in the chancel and two new windows were placed in the north wall of the north aisle. There were also new windows at the west end of both the aisles. The restoration also involved repairs to the roof, new flooring, a modified heating system and new seating arrangements.

The Thornhill family presented the original eight bells to the church in 1870, which were manufactured at the foundry of Mears & Stainbank in London. Some recasting and work on the frame was required in the 1930s, but it was not until 1990s that major restoration work became necessary. At that time the bells were refurbished, retuned and rehung in a new steel frame. Then, in 1997,

Graveyard at Youlgreave parish church.

to celebrate its 50th anniversary, the Derby Diocesan Association of Church Bell Ringers made a gift of another bell to the church. The peal was augmented to ten bells when local donations enabled another bell to be purchased. Three more bells were later added to the peal and, although there are now thirteen bells in the belfry, only twelve will ever be rung at any one time – the reasoning relates to adjustments being necessary in order for the bells to be able to ring a true octave.

The twelfth-century Norman font made from porous red sandstone and supported on four circular shafts with a circular base, stands just inside the south door and displays a carved figure of a salamander. It was a long-held view in ancient mythology that the salamander was fireproof and, by extension, able to resist the fires of sin. From there it is but a short step to see just why the salamander is considered as being a baptismal symbol.

The font had originally stood in the church at nearby Elton, but, when the spire there collapsed the font was relegated to the churchyard while the church was rebuilt. It stayed there until 1833 when the vicar of Youlgreave, Rev Pidcock, noticed it and removed it to his vicarage to be used as a garden ornament. Some years later, Rev Wilmot, Rev Pidcock's successor, realised the significance of the font and had it installed in the church. However, when it came to the notice of the parishioners of Elton they demanded the return of their font, but the parishioners of Youlgreave refused. In order to avert a damaging dispute, Mr Thornhill commissioned an exact replica to be made at his own expense and presented it to the church at Elton.

Location: **DE45 1WL**

3. St Michael with St Mary's, Melbourne

A priest and a church on the royal manor of Melbourne are referenced in the Domesday Survey of 1086. The bishopric of Carlisle was founded by Henry I in 1133, and one of the first endowments was the church of Melbourne. The first Bishop of Carlisle, Adelulf (Aethelwulf), died in 1156 and the See remained vacant for nearly half a century. Then, on 7 March 1202, King John presented Henry de Derby to the Bishop of Chester, declaring that it was in the king's gift owing to the vacancy in the See of Carlisle.

The Norman architecture of the church is a cruciform structure, with a tower in the centre, chancel, transepts, nave with side aisles, and a western portico flanked by two small towers. It is considered that the original Saxon church was perhaps founded by Ethelred on the death of his queen, but was later replaced by the current Norman church circa 1090.

It is considered by some that the present church was built on land which was part of a royal manor owned by Henry I. The 'royal pew', for the exclusive use of the king, would have been in the gallery at the west end of the church, and the galleries leading to the upper chancel would also have been exclusively for the king's use.

Entrance to the church from the west is gained through the semicircular doorway. Chevron mouldings are a feature on the five horseshoe arches that

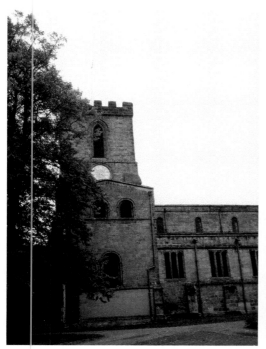 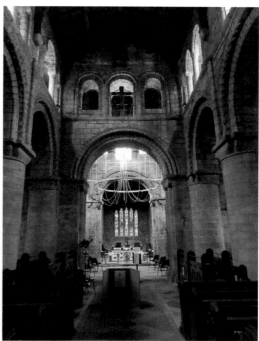

Above left: St Michael with St Mary's Church, Melbourne.

Above right: Looking from the nave, with its typical solid Norman arches, towards the altar and the superb stained-glass east window.

separate the nave from the aisles on each side. Apart from the sculptured capitals on the 4-foot-diameter circular pillars that support the arches, they are otherwise unornamented. Directly above the nave arches are arcades opening on clerestory windows, but those on the north side are different from those on the south side and date from different times. The work on the south side follows the Early English style of architecture and can be dated circa 1250.

On the north side of the transept arch are fragments of a thirteenth century wall painting that shows the demon Tutivillus. Tutivillus worked for Belphegor, Lucifer or Satan. His role was to introduce errors into the work of scribes, but in this painting he is seen hovering over two women who are arguing. Originally, much of this wall – which was painted to convey a message – would have shown the damnation of sinners and their subsequent suffering in Hell.

Structural alterations were made in the fifteenth century and then, between 1859 and 1862, further restoration work was carried out under the watchful eye of Sir George Gilbert Scott. The church was closed when work commenced, and was not reopened until 3 November 1860, when it was considered that it was safe enough to be used for worship. During the period of restoration the aisles were floored with Mansfield stone, a completely new pulpit and reading desk were

Above: The 'squint' is on the north side of the chancel arch and terminates in the transept.

Left: The Early English font, which was commissioned during the reign of Henry III.

installed and Minton encaustic tiles were laid in the chancel. Other renovations included the covering of the two western towers with pyramidal slated roofs.

The embroidered altar cloth in the chancel shows St Michael slaying the dragon. St Michael is flanked by angels on either side. There is a stained-glass window in the chancel showing the Crucifixion. The window also shows the Virgin Mary and St John.

On the north side of the chancel arch and looking through the pier is a 'squint', which terminates in the transept. Originally, there was a corresponding 'squint' on the opposite transept to the high altar, but this has since been removed.

The 28-inch-diameter circular font, which is supported by four columns with a central stem stands under the south portico. It is believed that the Early English font was commissioned during the reign of Henry III.

There are records dating from 1542 that state that there was a sanctus bell in the church steeple. There were structural changes made to the church between 1602 and 1610, when the height of the original Norman tower was increased and the chancel partially rebuilt. By 1732, and probably somewhat earlier, the central tower housed four bells bearing the inscriptions:

I. God Save the Church 1610 (with the founder's mark of Henry Oldfield)
II. I Sweetly Tolling Men Do Call To Taste of Meats That Feed the Soul 1632 (with the founder's mark of George Oldfield)

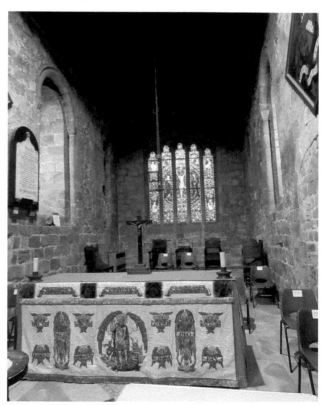

Altar and east window.

III. William Revitt and Henry Muggleston Churchwardens 1614 (with the founder's mark of Henry Oldfield)
IV. John Cooper, Jo. Fisher, D.W. and J Hedderley Made Me 1732

Another two bells were added at the time of the tower restoration of 1882, when the tower's original four bells were recast. When the nation celebrated the Golden Jubilee of Queen Victoria's accession to the throne in 1887, another two bells were added as a lasting memorial. The bells were rehung in 1897 and again in 1936.

In 1995 Eayre & Smith Ltd (bell hangers) removed the bells and wooden frame and installed a new metal twelve-bell frame. Another four bells, cast by Eijsbouts of Asten in Holland, gave Derbyshire its first ring of twelve bells.

The original organ was built in 1860 by Bevington and Sons of Soho. The organ was located in the organ gallery in the south transept. In 1956 Kingsgate, Davidson and Co. of London built a new detached console in the north side of the chancel and direct electric action was installed. Further remedial work on the organ was carried out by Nicholson & Co. (Worcester) Ltd in 1981.

The flags of Australia and the city of Melbourne hang in the west aisle of the church; the significance being that a province of Australia was named Victoria when Queen Victoria ascended the throne, and the province's capital, Melbourne, was named after William Lamb, Lord Melbourne, who, at that time, was the prime minister of England.

The Melbourne branch of the Royal British Legion has the distinction of being one of the oldest branches in the country.

Location: **DE73 8JH**

4. St Peter and St Paul's, Eckington

Eckington derives its name from its Saxon origin, meaning the township of Ecca. At the time of the Domesday Survey the manor of Eckington belonged to Ralph FitzHubert, although Eckington is first mentioned in the will of Wulfric Spott in 1002, when the manor was bequeathed to Morcare.

It is thought that the original Saxon church was of wooden construction, as was usual at that period, but that it was destroyed during the troublous times immediately preceding the taking of the Domesday Survey.

The parish church of St Peter and St Paul has the saints' names conjoined because it is thought by many that both Apostles met with their deaths on the same day – 29 June AD 65. (This is not a universally held view.) The church building itself features a nave, chancel, north and south side aisles and a tower surmounted by a spire at the west end. Originally the tower contained a peal of six bells, but it was decided that the bells should be broken up and recast into a peal of eight. In the bell chamber there was also a small sanctus bell, bearing the date 1737 and the initials B.H.F. Subsequently, the bell was recast and used as a service bell. At the time of the Reformation the use of all bells during service time was strictly prohibited, that is with the exception of 'Sermon bells'. These bells were usually rung for a few minutes before the start of the sermon for the benefit of parishioners who attended for only that part of the service, or, conversely, for members of the congregation who wished to leave before the sermon commenced.

Parish church of St Peter and St Paul, Eckington.

South porch and entrance, Eckington parish church.

On each side of the nave, five semicircular arches supported by large pillars separate the side aisles from the nave itself. The pillars are round, with the exception of the two nearest the tower, which are octagonal. The narrow arches indicate that they date from the plain early Norman period, thus suggesting that the church was first erected by Ralph FitzHubert, or his immediate successors, towards the end of the eleventh or the commencement of the twelfth century. The semicircular west doorway into the tower is also of Norman origin. The archway leading to the chancel is, however, an example of the Early English period, as is the tower. There are two lancet windows above the Norman doorway and above them there is another very small window. The squat spire, ornamented with four small windows, is from the Decorated period and can be dated to the middle of the fourteenth century – somewhat later than that of the tower itself. The Priest's Well, which can be seen in a field at the back of the church, is where, in former days, the parish priest drew water for the needs of the church. The church also has a very elaborate squint or hagioscope. The function of the squint was to ensure that worshippers, whose view might have been otherwise interrupted by intervening pillars or walls, could see the altar when the host was elevated during the service. The squint is located at the east end of the north aisle, in the wall that forms the support of the north side of the chancel arch.

In 1763 John Platt, the statuary mason and architect from Rotherham, was commissioned to add the south aisle porch.

The church was closed for some time between 1877 and 1878 while extensive restoration work was carried out: open benches replaced the more traditional

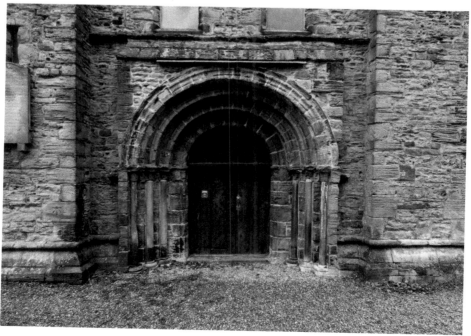

Great west door, Eckington parish church.

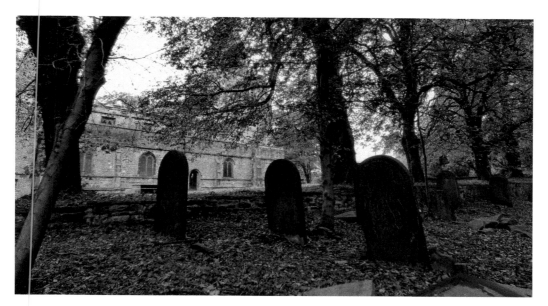

Above: Ancient
graveyard, Eckington
parish church.

Right: Early image of
Eckington parish church.

box pews; the three galleries in the south, west and north were removed; a new
Communion table, pulpit and lectern were added and a new stained-glass window
was commissioned. A brass cross for the reredos was donated by the Dowager
Lady Sitwell. The organ was also enlarged by the original makers, Brindley &
Foster of Sheffield. The church was reopened on 19 June 1878.

In 1907 the architect Percy Heylyn Currey was commissioned to remodel and
refurnish the church.

Location: **S21 4EP**

5. ST OSWALD'S, ASHBOURNE

At the time of the Domesday Survey, Ashbourn (Ashbourne) had both a priest and a church. The churches of Ashbourn and Chesterfield, and Mansfield and Ossington, in Nottinghamshire, were given by William Rufus to the Cathedral Church of St Mary of Lincoln, and to Robert Bloett, Bishop of that See on 5 December 1093, the day after Archbishop Anselm did his homage.

The building of the parish church in Ashbourne today is thought to have been started in mid-thirteenth century, with construction continuing until early in the fourteenth century. However, Bishop Hugh de Pateshull, Bishop of Coventry and Litchfield, considered that the building was suitable for worship and dedicated the church to St Oswald of Northumbria on 24 April 1241, as a brass plaque in the chapel on the south side of the church testifies. St Oswald's is built in the traditional cruciform style, and consists of a chancel, north and south transepts, and a nave. The nave was widened by the addition of south aisle, sometimes known as a double nave, later in the century, but a north aisle was never built – maybe as a result of the Black Death being prevalent in the area.

In 1330 that Antony Bek, Dean of Lincoln, gave instructions for the upper stages of the tower and spire to be built. The tower, which is surmounted by an octagonal spire, rises from the centre piers to a height of 210 feet, but, being in such an exposed position it has often been damaged by high winds, as was the case in February 1698 and again in 1783 and 1873. On these occasions the upper part

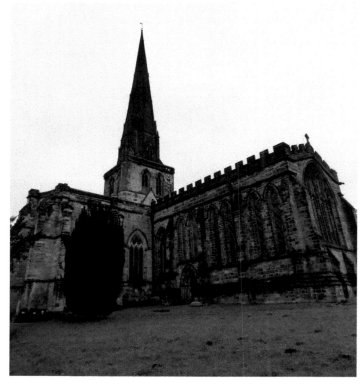

St Oswald's parish church, Ashbourne.

of the spire was taken down and rebuilt. In 1931 the tower was re-strengthened and the bells were rehung at a lower level. At that time a spring was found to be running directly under the tower, which might, in part, account for the need to strengthen and support the weight of the tower and spire. Local legend suggests that the spring was a site for pagan worship. In earlier excavation work a Norman crypt was discovered, causing speculation as to whether there had been a Norman church on the same site.

The church itself has regal proportions, the chancel being 65 feet in length and some 25 feet wide, with the total length of the church being 180 feet; the transepts are divided by piers and arches and are 85 feet in length and 40 feet wide. The height of the nave is 55 feet. There are chapels in both the north and south transepts, having monuments to the Cokayne (Cockayne) family, the Bradbourne family and the Boothby family. The monuments include effigies of John and Sir Edmund Cockayne, and tombs for members of the Bradbourne family. The Bradbourne tombs were originally in a chapel in the south transept but were moved around 1840. The most poignant of the Boothby monuments is that of Penelope Boothby, the only daughter of Sir Brooke and Lady Susanna Boothby. She was born on 11 April 1785 and died when she was just five years old. Her death was a great loss to her parents, a tragedy from which they never recovered.

Between 1837 and 1840 much restoration work was conducted by Lewis Nockalls Cottingham. Further significant remodelling work, which included the addition of battlements to the chancel, was carried out during the 1870s under the direction of Sir George Gilbert Scott.

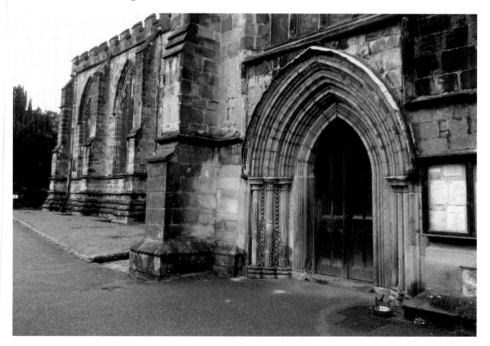

South door at Ashbourne parish church.

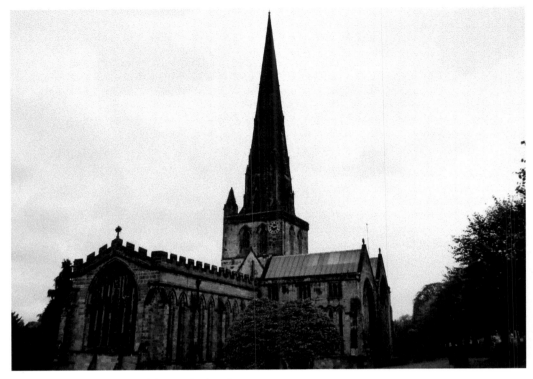

East window, St Oswald's parish church.

Some of the stained glass in the church dates from the time of its consecration in 1241, but many of the windows are from a later period. There are six lancet windows on each side of the chancel, two triple-lancet windows in the north transept, and one in the north side of the nave. The east window is by the renowned glass designer Charles Eamer Kempe, and the south transept window is by John Hardman Trading Co., Ltd. The first window in the south aisle, the so-called Turnbull window, is by Christopher Whitworth Whall. The window commemorates the lives of Monica Peveril Turnbull (aged twenty-two) and her sister, Dorothea Peveril Turnbull (aged twenty). The girls were the only children of Mr and Mrs Peveril Turnbull. As they were leaving the dining room of their home at Sandybrook Hall the candle that their father was carrying fell, setting fire to Dorothea's dress. Her sister, Monica, immediately went to her aid, but her dress also caught fire. Sadly, both girls died as a result of their injuries.

The three saints depicted in the window are St Barbara, St Cecilia and St Dorothea. The faces of St Barbara and St Dorothea are in actual fact the faces of Monica and Dorothy, while the face of St Cecilia is an image of Whall's own wife.

Henry Valentine of Leicester delivered and installed an organ on 10 May 1710, which was replaced in 1826 by an organ built by Parsons. The present organ,

Right: Early image of the nave of St Oswald's Church, Ashbourne.

Below: Early image of St Oswald's Church, Ashbourne.

installed in 1858, has had several restorations over the years, the most recent being carried out by Henry Groves & Son of Nottingham.

There is a ring of eight bells at St Oswald's, which replaced the ring of six bells that were installed in 1664. The current bells were cast by William Dobson of Downham Market in 1815.

Location: **DE6 1AN**

6. ST WYSTAN'S, REPTON

In order to bring about the conversion of his kingdom of Mercia to Christianity, King Peada founded a monastery here around 653 and brought four priests over from Lindisfarne. One of them, Diuma – a Scottish missionary – was consecrated as the first Bishop of Mercia in the year 666. He was buried at Repton just two years later. For many years Repton was the capital of the kingdom of Mercia, and the first Christian church of the converted Saxons in the Midlands was built in the area. Sometime later the bishopric was removed to Litchfield.

The wooden church was destroyed by fire in 873 when marauding Danes advanced on Repton, seized the town and, in so doing, completely destroyed the monastery, which had borne witness of the Christian faith for over 200 years.

The earliest surviving areas within the current church are the east end of the nave, the upper walls of the chancel and the eighth century crypt, built during the reign of King Æthelbald, and thought to be a relic from the Saxon abbey founded here in the seventh century even predating the Viking invasion of 873. Originally constructed as a baptistery, the crypt was later used as a mausoleum for Mercian kings.

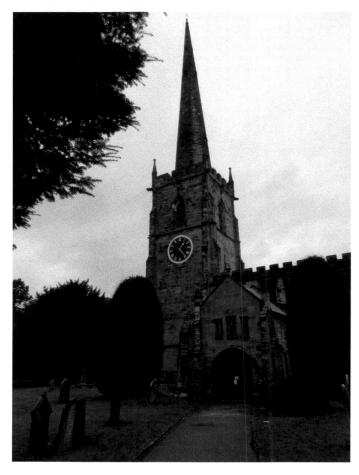

Parish church of
St Wystan, Repton.

St Wystan, the son of Wigmund of Mercia and Ælfflæd, died in 849 when, on 1 June – the eve of Pentecost – he was brutally murdered by his cousin, Beorhtfrith (Berfert). His body was carried to the crypt at Repton and buried in the tomb of his grandfather, King Wiglaf. Following claims of many miracles occurring after the saint's death, the crypt later became a place of pilgrimage. Indeed, because of the influx of so many pilgrims, passages needed to be cut from the north-west and south-west corners of the crypt in order to facilitate safe entry and exit. When the chancel was re-floored the crypt was hidden from view for many years. Then, in 1779 it was rediscovered when, purely by chance, a workman who was digging a hole for a grave accidentally breached the vaulting of the crypt. However, because of its increasing popularity as a centre of pilgrimage, Cnut the Great had Wystan's relics removed to Evesham at the beginning of the eleventh century.

During the reign of Edgar the Peaceful, 958–75, religious ardour among the Saxons was such that a parish church was built on the site of the ancient abbey at Repton. The church was dedicated to St Wystan.

St Wystan.

Looking from the nave towards the east window, St Wystan's, Repton.

The church consists of a nave, north and south aisles, south porch, chancel and a tower that is surmounted by a spire. With the exception of the Norman style of architecture, St Wystan's has examples of most of the major styles of medieval building in England.

The fourteenth-century tower is at the west end of the nave. The tower is surmounted by a lofty spire rising to 210 feet. Over the years there has been much speculation as to exactly when the tower and spire were built, but it is now generally accepted that they were built and completed in 1340, but modified sometime later in the fifteenth century. The tower has a central aperture 54 inches in diameter, which allows the raising and lowering of the bells. A daring feat was performed in 1804 when Joseph Barton attached a line of twelve ladders to the south-eastern side of the spire, carefully climbed them and brought down the weathercock. After being repaired Barton replaced it in its rightful position. Villagers made a collection to thank him for the task he had performed. More recently there has been major work carried out on the spire and tower. In addition to repointing, a number of the upper courses have been removed and replaced.

The nave was lengthened during the fourteenth century by the addition of four arches being built on each side and standing on hexagonal piers. Many of the windows of the south aisle also date from this period. The south porch was also added at this time, although probably later in the century.

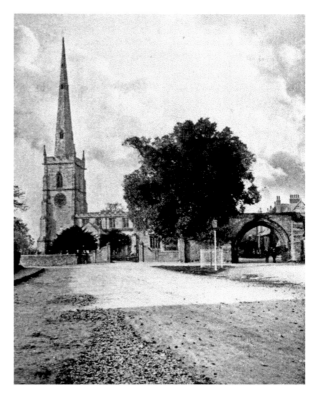

Right: Early sketch of St Wystan's
Church and priory gateway, Repton.

Below: Sketch of the crypt under
the chancel at St Wystan's Church,
Repton.

In the Perpendicular period of the fifteenth century, the high-pitched roof of the nave was removed, the walls above the nave arcades were raised by several feet and replaced by a nearly flat roof, and seven two-light clerestory windows were inserted on each side.

The 'singers' gallery' was added over the west end of the nave in 1719. Over seventy years elapsed before any other significant structural changes were made at St Wystan's. At that time, 1792, the old box pews were replaced with high box pews; the level of the church floor was raised; a central three-decker pulpit was installed and the 'singers' gallery' was enlarged. Some of the church's ancient monuments were also removed at this time.

When roof repairs became necessary towards the latter end of the nineteenth century, the opportunity arose to undertake some general restoration. The floor was returned to its former level, the south aisle wall was rebuilt and the gallery above the west end of the nave was removed.

During the 1920s electric lighting was installed in the church, as was a completely new central heating system.

When the pipe organ was removed from the south transept in 1950, the whole area was re-floored and furnished to become the Fynderne chapel. There were further alterations in 1998 when the organ was replaced and relocated to the chapel.

It is thought that, judging from the founder's mark, the oldest bell at St Wystan's, the sixth, dates from 1513, although there is some debate as to whether the bell was actually founded before or after that date, as there is no indication of the date on the bell itself. The first recorded reference to the bells at St Wystan's dates to the churchwarden and constable's accounts of 1583. At that time one of the bells was taken down, recast and reinstalled. In 1896, when there was a ring of six bells in the tower, the bells were overhauled and repairs effected on the cracked fifth and sixth bells. All six bells were then set on new frames. A further two bells were installed in 1935 by John Taylor & Co. of Loughborough.

Location: **DE65 6FH**

7. ALL SAINTS', BAKEWELL

Bakewell has been a centre of Christian worship since Roman times. A church was established here during the seventh century, when Celtic missionaries arrived from Northumbria and established a minster church. At the time of the Domesday Survey, Bakewell was a place of some importance, having a church and two priests; with Repton, the ancient capital of the Mercian Kingdom, being the only other town in the county to share this distinction. The original church was demolished and replaced with a new building erected in, or around, 1110. Judging from the style of architecture, it would appear that William Peverel commissioned the church to be built – William Peverel was the illegitimate son of William the Conqueror and had been granted the manor of Bakewell by him. The narrow side aisles and nave retained the same dimensions, as indeed did the transepts and chancel. Much of the design of the Norman church of Bakewell closely resembled that of Melbourne, although subsequent alterations to the fabric of the church removed much of the Norman work. There is however a richly decorated

doorway at the west end of the nave and some traces of the old corbel table on the north side of the chancel. The west walls of the side aisles have large semicircular arches incorporated for additional strength, thus enabling the walls to bear the low western towers, which would have completed the original Norman design.

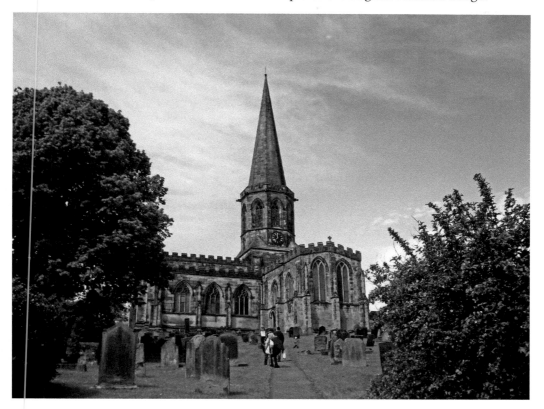

Above: All Saints' Church, Bakewell.

Right: In the churchyard are several stone coffins, one of which contained a leaden chalice, denoting that it was the tomb of a priest.

Dedicated to All Saints, the church is cruciform in plan, being about 150 feet in length, and 105 feet across the transepts. The nave has side aisles and a south porch. Completing the structure there are north and south transepts, and a large chancel. Resting upon the Early English base at the intersection of the transepts, nave and chancel is the Perpendicular-style octagonal tower, spire and battlements, which were added at the end of the fourteenth century. The south porch was added in the early part of the fifteenth century.

As the Early English period of architecture was becoming well established, alterations were being made to the original Norman church in or around 1250. At this time the south transept was rebuilt, extended and subdivided by a carved oak screen and the north aisle was widened. Other changes that were made included adding a clerestory, extending the chancel and replacing the round Norman arches of the arcade with architecture of a more contemporaneous style.

In 1829 an architect's report stated that the church was in a poor state of repair due to the weight of the steeple pushing the walls outwards. The report concluded that, if remedial action was not taken, it was likely to fall down. Following lengthy discussion, it was decided to restore the building to its original state. Extensive repairs of the whole fabric commenced in 1841, but were not completed until 1852. During this time the whole of the tower piers were taken down, and the tower and spire rebuilt to the original design.

During the restoration many original Saxon and Early English building blocks were recovered and reused, while others were preserved and displayed in the church.

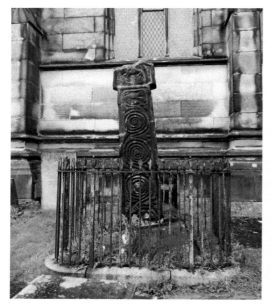

Above left: Ninth-century Saxon cross in the churchyard.

Above right: The mural sundial over the entrance bears the date 1793.

The church's stone pulpit dates from the nineteenth century, but the carved tub font, located inside the south door, dates from the fourteenth century. The carved figures represent the Virgin Mary, St John the Evangelist, St Peter carrying the keys of Heaven, St Paul and St John the Baptist together with an unidentified bishop and priest.

Ninian Comper created the reredos of the Crucifixion with the Virgin and St John, which is in the chapel of St Michael and St George in the north transept.

A stained-glass window by Charles Eamer Kempe can be seen at the back of the north aisle.

A scene depicting the Resurrection and Communion of the Saints is shown in the chancel windows. The twelve Apostles, together with their symbols, are depicted on a carved marble frieze above the high altar. There is also a carved wooden reredos of the Crucifixion, which also shows the grieving figures of the two Marys and a number of Roman soldiers on horseback.

The oldest tomb in the church is that of Sir Thomas Wendesley, who was killed in the Battle of Shrewsbury in 1403. The tomb is in the Vernon chapel, off the south aisle, as are the tombs of John Vernon of Haddon Hall and Sir George Vernon and his two wives.

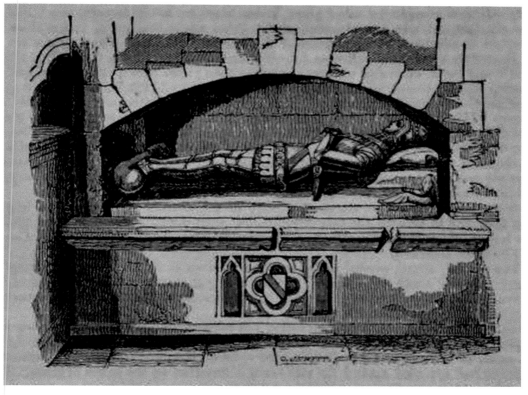

Sketch of the monument erected to the memory of Sir Thomas Wendesley, who was mortally wounded at the Battle of Shrewsbury.

The churchwarden's chest dates from 1538 and was originally used to store church valuables and parish records.

There are two ninth-century Saxon crosses in the churchyard where, in the tenth century, there stood a Saxon church. More examples of Saxon stonework, displayed in and around the church porch, were found during the restoration work in the 1840s.

Location: **DE45 1FD**

8. St Wilfrid's, Egginton

Eghintune (Egginton) had a priest, a church, a mill, and six farmers at the time of the Domesday Survey, when the manor was held by Geoffrey Alselin. Later, by way of marriage, the manor was held jointly by Amalric de Gasci and William FitzRalph. This meant that there were two rectors in the manor at the same time. As with the manor, the rectory of Egginton was divided into two sectors – 'moieties' as they were called at the time.

In 1345 Bishop Norbury appropriated the half rectory of Egginton to the abbot of Dale and his twenty-four monks. The bishop stated that his reasons for taking this action was solely in order that the monks could continue with their custom of hospitality, noting that many people visited the abbey every day for food, as it was some distance from towns.

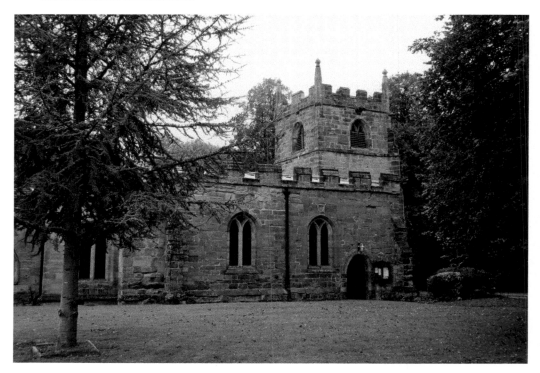

Parish church of St Wilfrid, Egginton.

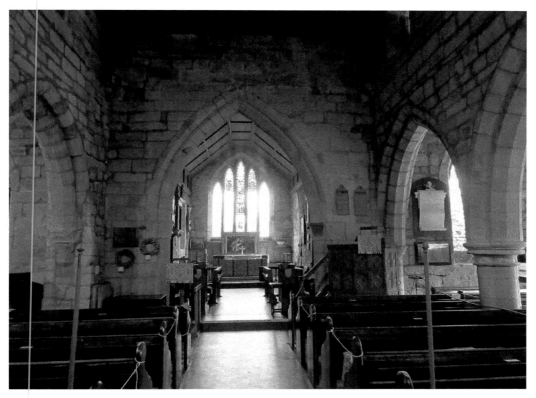

Looking from the nave towards the east window and chancel.

The conspirator Sir Anthony Babington of Dethick, leader of the unsuccessful 'Babington Plot' to assassinate Elizabeth I, was hanged, drawn and quartered in 1586. The following year the queen awarded his possessions to one of her favourites, Sir Walter Raleigh. Among the Derbyshire property gifted to Sir Walter was a fourth turn of presentation to the church of Egginton, although just why this was included in the gift is not certain.

A Norman church once stood on this site, but there remains no evidence of the fabric of this earlier church. It appears that the church, which is dedicated to St Wilfrid, was almost completely rebuilt towards the end of the thirteenth century. The church has a chancel, nave, aisles, north vestry, and low west tower. The tracery of the large east window of the chancel, which dates from the time of rebuilding, is divided into five lancets without any foliations.

The church dates from the twelfth century, but does have elements from the fifteenth, sixteenth and seventeenth centuries.

There is evidence in the chancel of some of the old stained glass. Depicted in the east window, which was cleaned and repaired in 1984, are four different figures: one that represents Our Lord on the Cross; another, the First Person of the Trinity; and the side windows appear to be the Virgin Mary and St John. Closest to the nave on the south window of the chancel, two figures are represented, the first

being a kneeling man dressed in a blue robe. He holds a rosary in his hands and, somewhat incongruously, sports a dagger in his belt. The other figure appears to be either a bishop or an abbot, but it is difficult to determine as the head is missing. The border of this window is a crown-and-lozenge pattern. The window itself would appear to date from the end of the fifteenth century.

The south aisle dates from 1320. The aisle is separated from the nave by arches that are supported on columns formed of four clustered shafts. The south doorway is of the Decorated period. The window on the north side also dates from the early Decorated period. The arcade consists of three bays that are supported by circular columns. The lancet window on the north aisle has a trefoil head. Originally the east window of this aisle was similar but has since been replaced by a three-light Perpendicular window, circa 1400.

There are three two-light clerestory windows over the south arcade and two very small square clerestory windows over the north arcade dating from the Decorated period.

Between 1891 and 1892, Evans and Jolly of Nottingham was charged with completely restoring the church's fabric. The restoration work included re-laying the church floor with red tiles in the aisles and wooden blocks under the sets; installing a new oak roof over the nave and north aisle; building an organ chamber between the east end of the north aisle and the vestry, and moving the window,

The shelf on the north aisle wall where Francis Bugbury willed that, on every Lord's Day, twelve penny loaves should be placed there for twelve needy parishioners. (Courtesy of Mrs Katherine Marples)

Right: Long case containing Bishop Every's pectoral cross, pastoral staff and ring.

Below: The medieval scratch dial, or Mass dial, on the outside of the south wall of the chancel. (Courtesy of Mrs Katherine Marples)

which was formerly in the chancel, to the organ chamber. Also, a new window in memory of Revd Rowland Mosley was installed, and some fragments of ancient glass in the east window were re-leaded and replaced. On 1 April 1892 the church was reopened by the Bishop of Southwell.

The tower, which has debased battlements and pinnacles, is of the Perpendicular period. There is no west door. The mark '1593, B.S., W.K.' is carved high up in the outer wall of the north aisle. In all probability this relates to the date of the battlements of the north aisle. The stark embattled features of the church would strongly suggest that the church, in addition to being a place of worship, also served as a sanctuary in more troubled times. The tower contains three bells:

 I. 'I was recast again to sing
 By friends to country church & king.
 Thomas Hedderley founder Nottingham 1778.'
 II. II ' Ihc. Ave Maria gracia plena Dominus tecum.'
 III. 'I sweetly toling men do call
 To taste of meats that feeds the soole, 1615.'
 The bell mark of Henry Oldfield.

In 1897 the bells were rehung by the parishioners to celebrate Queen Victoria's Diamond Jubilee.

There is a medieval scratch dial, or Mass dial, on the outside of the south wall of the chancel. Scratch dials were in common use between the Norman Conquest and the introduction of mechanical clocks towards the latter part of the thirteenth century.

An interesting feature of St Wilfrid's is a small wooden shelf on the wall of the north aisle. The shelf was placed there on the instigation of Francis Bugbury who willed that, on every Lord's Day, twelve penny loaves should be placed there for twelve needy parishioners. The bequest only ended when bread rationing was introduced at the beginning of the Second World War.

Another significant historical feature over the north door within the church is the royal coat of arms dated 1815, the year of the Battle of Waterloo.

Displayed in a long case on the west wall are Bishop Every's pectoral cross, pastoral staff and ring. Bishop Every was Anglican Bishop of South America and the Falkland Islands from 1910 until 1937, returning to England to become Assistant Bishop of Derby and rector of St Wilfrid's until his death in 1941. The case also contains the flute and clarionet that were presented to the church in 1912 by Mr Thomas Hulland. They had been used in the church, together with a bassoon and violoncello, to accompany the singing before the organ builders Forster and Andrews of Hull built and installed the first organ in 1892.

The oak reredos at the high altar was gifted by Mr Moseley of Calke. The picture of the Virgin and infant Christ with the young St John the Baptist was donated by Joseph Leigh in 1833.

The panelled pulpit at the entrance to the chancel was presented by Sir Edward and Lady Every on the occasion of their Silver Wedding.

Designed by Sarah Burgess, the reinstalled – 2003 – west tower window depicts St Wilfrid and shows some of the landscape around Egginton.

Michael Stokes of Nottingham designed and crafted the modern glass in the south aisle window, taking as its theme 'I am the resurrection and the life'.

The north chancel window was designed and installed by the Charles Eamer Kempe studio.

Location: **DE65 6HS**

9. St Matthew's, Pentrich

At the time of the Domesday Survey the manors of Pentrich and Ripley were held by Levenot under Ralph FitzHubert. No reference is made of St Matthew's Church in the survey, but it is recorded in a Darley cartulary dating from the reign of Henry II that the church of Pentrich, with all its appurtenances and liberties, was given to the canons of Darley Abbey. All that remains of this earlier Norman church are the five arcades that separate the aisles from the nave, the lower part of the tower and parts of the south aisle and west wall. The 4-foot-thick walls at the base of the tower are indicative of the Norman period, a fact that is further confirmed by the lack of a stone staircase, which were rarely or never found in the small churches of that period. The small round-arched door leading from the nave into the tower is also of the period.

Originally dedicated to St Helen, the parish church at Pentrich is now dedicated to St Matthew. Much of the church is built of local sandstone, with gritstone being used for the chancel and battlements. The church has a nave, north and south side aisles, a porch, chancel, and a short embattled tower at the western end. Inside the church, the arches that separate the side aisles from the nave bear a striking resemblance to those that can be seen in the church of St Mary at Crich. The circular arches, together with the pillars that support them, are of the late Norman period and are dated *c.* 1150.

At the time of the Dissolution of the Monasteries, the lands held by Darley Abbey at Pentrich and Ripley were granted by the crown to Zouch of Codnor, but were later sold to the Duke of Devonshire. The patronage of the parish continues to be held, jointly, by the Duke of Devonshire and the Wright Trustees.

There is no evidence of the Early English or the Decorated styles, but *c.* 1480 the church was enlarged and refurbished in the Perpendicular style. The clerestory windows above the arches of the nave and the windows of the side aisles are of the Perpendicular style. Similarly, the belfry windows and the embattlements of the nave, side aisles, porch and other external details of the tower are of the same period.

In 1859 the Duke of Devonshire paid for the whole of the church to be reordered, which included the installation of a stained-glass east window and the church being re-pewed and re-roofed. The church reopened on 28 March 1860. Further reordering took place in 1875, which included relaying the church floor with encaustic tiles, rearranging the choir stalls, bringing the reading desk from the nave into the chancel, reducing the height of the pulpit, placing a piscina of

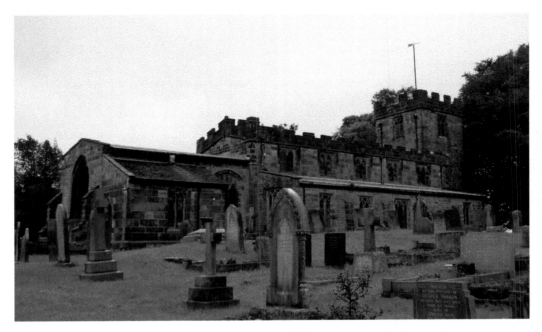

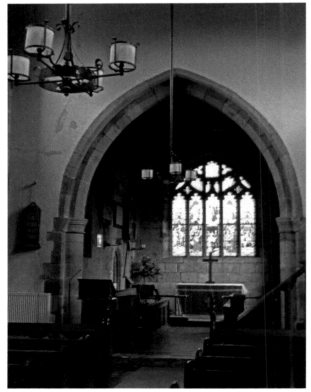

Above: Parish church of St Matthew, Pentrich.

Left: Looking towards the chancel, showing the east window, which was installed in memory of Revd G. H. J. Pocock.

Caen stone in the south wall of the chancel, and moving the organ from the west end of the nave to the east end of the north aisle.

During his incumbency in the late nineteenth century, Revd William Jellicorse Ledward painted a fresco on the west wall of the nave depicting the calling of Matthew by Jesus.

Standing at the west end of the nave, the twelfth-century font was banished from the church during the Commonwealth, but was subsequently restored to its present position in 1662, although the decoration on the bowl is more typical of the Norman period. The upper part of the font is of Derbyshire gritstone and has a broad band around the top which is heavily moulded with plain round arches on cushion capitals. The font went missing again during the nineteenth century and was later found in the cellar of a former churchwarden of the church, the font having been used for beef salting.

Originally there was a ring of three bells in the tower, but this number was added to in 1869 when another two bells were installed, supplied by Messrs Taylor of Loughborough. The installation of the additional bells did however necessitate considerable strengthening of the original oak frame so that all the bells could be fitted into the tower.

St Matthew's now has a ring of six bells; the sixth bell was cast as recently as December 1993 by the Whitechapel Bell Foundry of London. Two of the bells,

Norman arches in the nave.

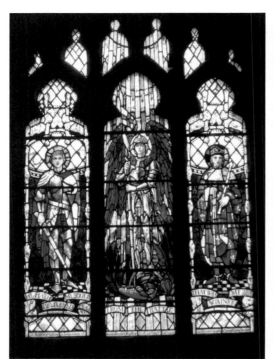

Above left: The stained-glass window on the north wall is by Christopher Whitworth Whall and is dedicated to Bernard Winthrop Smith, who died at Ypres in the First World War.

Above right: The Martha and Mary window, by William Morris, at the east end of the nave.

the third and the fifth, are medieval and subject preservation orders. The oldest bell, the fifth, was cast by Richard Seliok of Nottingham and dates from the early sixteenth century.

In 1995 a restoration programme included the retuning of the five older bells, the aim being to improve the overall harmonics of the ring.

There is a scratch dial on the exterior of the south chancel wall; the dial, or Mass clock as it was more usually called, was used by the priest to inform parishioners when the next service was due to begin.

The three-light painted-glass window, circa 1915, to the chancel north wall is the work of Christopher Whitworth Whall, whereas the painted-glass window at the east end of the south aisle is by Morris and Company. There are monuments to Edward Horn and Madam Mower on the chancel north wall.

Location: **DE5 3RE**

10. St Peter's, Hope

There was a church in Hope before the time of the Norman Conquest. At the time of the Domesday Survey the royal manor of Hope encompassed a significant area, having seven berewicks within its boundaries, including the

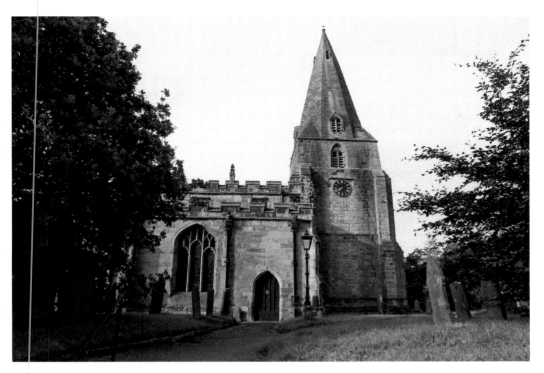

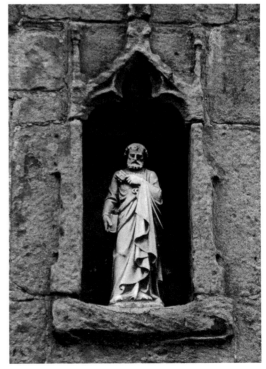

Above: Parish church of St Peter, Hope.

Right: Statue of St Peter.

hamlet of Tideswell. The Saxon church established at Hope had a priest and land equivalent of one carucate – the amount of land that could be kept in cultivation by a single plough.

The parish of Hope was one of the largest in England when it was first recognised as a parish. The church, dedicated to St Peter and thought to occupy the same site as the original Saxon structure, consists of nave, north and south aisles, south porch, chancel, and a 'broached spire' at the west end. Evidence of building during the Decorated period can be seen in the outer walls of the church, the south doorway, the 'broached spire' and, on the inside, the arches and columns in the nave. The exterior characteristics of the parish church of Hope predominantly demonstrate the Perpendicular architecture of the fifteenth century; notably seen in the south porch, the low-pitched roof and battlements, the windows of the north and south aisles, the chancel, and the eight clerestory windows. The small window in the west wall of the tower represents the Draught of Fishes. The bell chamber is lit by four pointed windows of two lights. There are four similar windows standing out from the spire, with another course of a single light above them.

It appears that the church, together with the tower and spire, was completely rebuilt at the beginning of the fourteenth century. The piscina in the south wall of the south aisle, attributed to the Early English work of the previous century, being the only remnant of the older building.

In 1733 the four bells in the tower, as they were then, were 'very much decayed and out of tune'. An agreement was signed between the church wardens and the bell founder Daniel Hedderly, of Baltry to recast and retune the bells and add another to the peal. It is thought that the Duke of Devonshire also added a sixth bell at this time. The other two bells being added at a later date.

When the chancel was rebuilt in 1881–82 a Perpendicular-style east window was also installed. Further restoration of east end of the chancel was carried out in 1908 by Charles Hadfield of Sheffield, when a stone screen and marble reredos was erected behind the altar. Also added at that time were five stained-glass windows designed and made by Charles Eamer Kempe, which included an enlarged east window, two smaller windows on the north side of the chancel, and the two windows on the south side that together formed a series representing events of the Passion and the Resurrection of Our Lord.

Frederick Charles Eden designed and painted the two windows in the north aisle. The window above the altar is a representation of the Annunciation, and the second window represents the Nativity of Our Lord.

Another window in the south aisle designed and made by Kempe represents the Deliverance of St Peter by the Angels out of prison.

There is a niche over the outer door of the south porch that holds a statue of St Peter and not far from the porch there is a horizontal metal sundial. A carved Saxon cross shaft with foliage and knotwork also stands by the porch. Two of the projecting gargoyles around the church serve as rain spouts to the south aisle.

A rare painted hymn board, dating from 1806, incorporates a painting of David on the back. There are also four, full-length portraits that adorn the church walls.

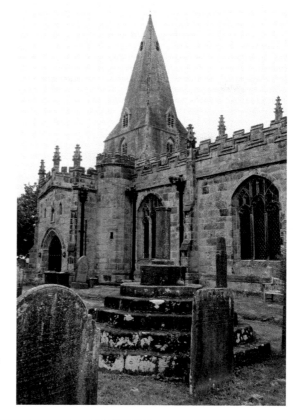

Right: Six octagonal steps with a horizontal metal sundial on the summit.

Below left: Shaft of a carved Saxon cross.

Below right: Detail of a gargoyle on the south side of St Peter's.

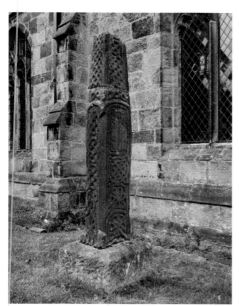

Two of the framed paintings are above the south door and date from 1733, and depict 'Aaron' and 'Life', and the other two paintings are above the north door and depict 'Moses' and 'Death'. The fourteenth-century octagon font, which sits on an octagonal base, is to be found under the west gallery. Within the Communion rails there are three seventeenth-century oak chairs. The largest, which bears the date 1664, is thought to be the chair of the schoolmaster of the Endowed Free School of Hope.

One of the more unusual practices/traditions at St Peter's often took place when weddings were held at the church. Just before the newly wedded couple were about to leave after the ceremony, a rope was placed across the church door and payment in the form of a toll demanded from the couple. Payments of another kind were reputed to have been made when a considerable trade in 'body snatching' allegedly developed between Hope and Manchester; in fact, one of the Entries of Burial has an additional note stating 'Body removed same night'.

Location: S33 6RD

11. St Giles', Sandiacre

One of the royal thanes, Toli, held Sandiacre under the king at the time of the Domesday Survey. It is recorded that there was a priest and a church on the manor. The predominant style of the church architecture is Norman; the inner door of the south porch is Norman, having three orders of shafts and cylindrical mouldings. There is also a large round-headed Norman window on each side of the nave. Similarly, the chancel arch is Norman. The Norman tower was taken down and rebuilt in the thirteenth century. There is also evidence of a Saxon church that was standing when the Domesday Survey was compiled in 1086.

The present church was founded in or around 1160, although the chancel was not added until 1342. Dedicated to St Giles, the church has a chancel, clerestoried nave, south porch and a west end tower surmounted with a low broached spire. Also on the south side are three sedilia and a piscina, which are placed under four high canopies.

Originally, the lower part of the tower was from the Norman period, but the tower of that period was taken down, almost to its foundations, and rebuilt at the beginning of the thirteenth century during the Early English period, having long narrow double lancet, louvered bell openings in the south and north walls. It would appear that the tower was built with a considerable time lapse from its early construction to its completion at the start of the Decorated period. The two-light bell chamber windows are from that period, as is the broached octagonal stone spire with its two tiers of cusped ogee-headed lucarnes on all four sides.

There is a Saxon window over the arch, but this is the only remains of an earlier church. Much of the church, including the chancel arch, the round-headed windows in the nave and the inner door of the south porch all belong to the Norman period.

The spacious Decorated chancel is one of the most, perhaps the most, remarkable features of this church. The prebend of Sandiacre between 1342 and

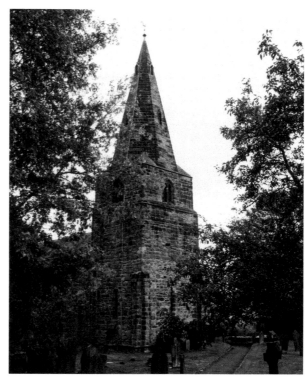

Right: Parish church of St Giles,
Sandiacre.

Below: An early image of
St Giles' Church, Sandiacre.

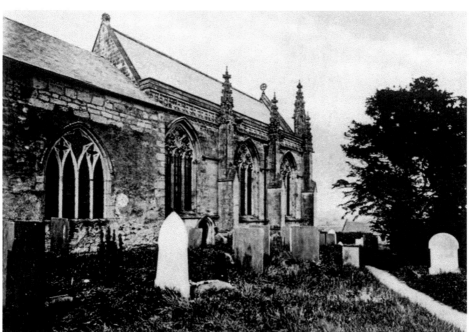

1347 was Roger de Norbury, Bishop of Lichfield, and it was his vision, largesse and guidance that led to the remarkably spacious chancel being constructed. There are three large windows on each side, each of three principal lights. Flanking the great east window between the side windows there are elaborate buttresses which are crowned with crocketed pinnacles.

There is an incised gravestone, or coffin lid, on the floor of the chancel, most of which was found under the pulpit in 1854, and the remainder was uncovered in the churchyard.

Standing 41 inches high at the west end of the nave is the large, fourteenth-century Decorated font, having a moulded octagonal base – typical of the period – with a waisted stem. The font cover is of a more contemporary period.

Major restorations were carried out in 1855 and 1866. Further work was carried out in 1883 when new pews, gas chandeliers and a new organ were installed. Also, the floor was relaid with Minton encaustic tiles.

Originally, the tower had a ring of three bells, thus inscribed:

I. 'God save the Church, 1650,' and the usual mark of George Oldfield.
II. 'God save the Church, 1608.'
III. 'God save the Church, our Queene, and Realme.' There is no date, but it is an Elizabethan bell, and bears a founder's mark, consisting of a bell on a shield, the whole within a circle, having the words 'I made bi Henri Ouldfeld' round it.

These three seventeenth-century bells were removed and replaced in 1881 by a peal of six bells, a gift from a parishioner, Joseph Stevens, who was a prominent lace manufacturer.

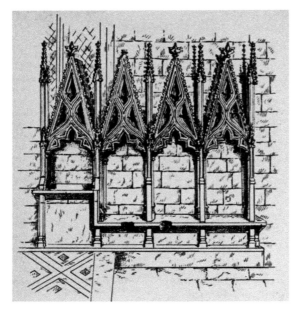

Sketch of sedilia.

In 1887, Matilda, Joseph Stevens's sister, had the stained-glass east window inserted in his memory.

Towards the end of the twentieth century it became apparent that the peal was too heavy for the tower. Following a major overhaul, a new bell frame was fitted and structural changes were made to the tower itself. During this time the two heaviest bells were recast and inscribed with the date of their recasting – 2012. The new ring was dedicated in 2013.

Nigel Church of Stamfordham, Northumberland, built a new pipe organ in 1977, with the organist David Butterworth acting in a consultative capacity.

The early twentieth-century pulpit, choir stalls and nave stalls are all of oak. The reredos, which also dates from the mid-twentieth century, is of painted oak and also has a number of carved figures.

On the south side of the Norman arch there is a memorial to the men of the parish who fell in the First World War.

Location: **NG10 5EE**

12. ALL SAINTS', KIRK HALLAM

Although there is no mention of a church in the manor of Kirk Hallam at the time of the Domesday Survey, it is known that sometime during the reign of Henry II the manor and church were held by Sir Peter de Sandiacre. Then, shortly after the foundation of Dale Abbey, Sir Richard de Sandiacre, Sir Peter's son, bestowed upon the monastery the whole right of patronage of the church of Kirk Hallam, as well as grants of lands and tenements. In fact, the church was directly administered by Dale Abbey until 1539, and up until that time the priests were monks from the abbey; the first recorded incumbent was a monk, Simon de Radford, in 1298. Even after the Dissolution of the Monasteries, the abbey continued to supply the vicars – a total of fifteen monk vicars, the last monk vicar being Roger Page.

The small aisle-less church of All Saints consists of chancel, nave, and a low embattled tower at the western end. Beak-headed Norman mouldings on each side of the south entrance form part of the old chancel arch. And, apart from that, the only other relic of the first church to be built on this site is the Norman font, resting on a base of Early English mouldings. In contrast, the three-light east chancel window is of Decorated design. There are also examples of Perpendicular work, notably the two square-headed two-light windows on the south side of the chancel, and three similar ones on the south side of the nave. The tower, which houses the church's three bells, is also an example of late Perpendicular work.

After the dissolution of Dale Abbey, the advowson – the right to appoint vicars – in Kirk Hallam fell to the influential Newdigate family towards the second half of the eighteenth century. But, by that time, the church was in such a ruinous state of repair it was in danger of being completely demolished. The alternative being for a petition to be sought requesting that a brief be obtained such that funds could be raised to completely rebuild the church. The brief was granted and, subsequent to that, an estimate for complete rebuilding was calculated as being somewhere in the region of £1,028. A public subscription was organised by the Newdigate

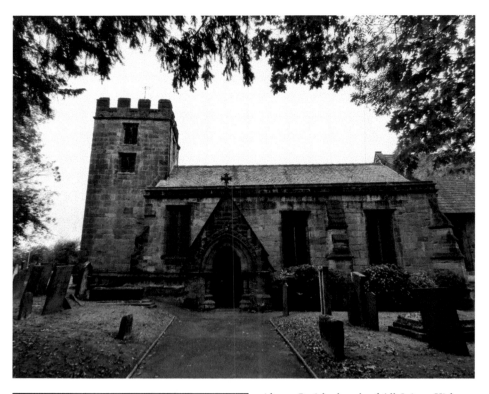

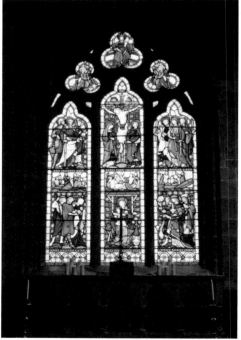

Above: Parish church of All Saints, Kirk Hallam.

Left: Altar and east window, All Saints' Church, Kirk Hallam.

family in 1858, but, as insufficient funds for rebuilding were raised, a programme of refurbishment was carried out instead. The architect appointed to be leading the restoration was Mr George Edmund Street of London. The work included the restoration of the nave, the erection of two new buttresses, a new porch, laying solid new foundations to the south wall, installing two new windows, a new tower arch, the floor being paved with Minton's tiles, the pews being replaced with open seating and the ancient font and internal walls being restored. But, when the restoration work was nearing completion there was still a significant shortfall in funds available to pay for the work. The building of a new pulpit and other fittings was postponed.

The church was reopened for divine service on Sunday 21 August 1859 and, in order to defray some of the outstanding funding deficiencies, a retiring collection was held following both the morning and afternoon services. The rural dean preached the sermon at the Holy Communion service that day.

The entire cost of the restoration work required on the chancel was financed by F. Newdigate Esq. and Lt Col Newdigate.

The Norman font on a base of Early English mouldings.

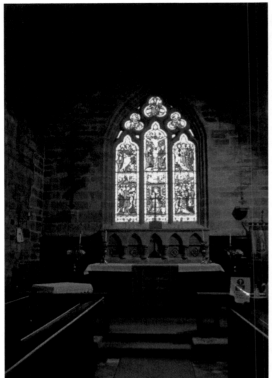 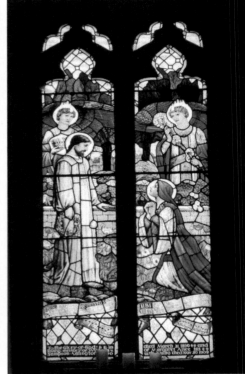

Above left: Chancel and altar, All Saints' Church, Kirk Hallam.

Above right: Stained-glass window dedicated to the memory of William Sampson Adlington and his wife Margaret Alice Adlington.

The original organ was built by Peter Conacher & Company of Huddersfield and dedicated by the Bishop of Derby on 7 May 1904. The organ was overhauled in 1982 by Henry Willis & Sons of Liverpool.

The three bells in the tower are inscribed as follows:

 I. 'Jesus,' in Lombardic capital letters, and on the waist the initials H. D.
 II. 'God save the King, 1666.' (The bell-mark of George Oldfield).
 III. Four Lombardic letters S, alternating with four crosses.

Kirk Hallam is not without its mysteries as Revd William Blurton, vicar of the parish from 1891 to 1911, would no doubt testify. When travelling home in his pony and trap from an evening engagement, he reported that while on his way he had seen 'a headless lady' pass him. The Ladywood ghost had clearly left her indelible image on him.

Location: **DE7 4ND**

13. ST CLEMENT AND ST JOHN'S, HORSLEY

The castle of Horeston, or Horsley, together with the manor of Horsley was held by Ralph de Buron at the time of the Domesday Survey, although at that time no mention is made of a church in the manor. However, it is on record that sometime between 1291 and 1304, during the reign of Stephen, the advowson of the church of Horsley was given to the priory of Lenton.

The church, dedicated to St Clement and St John, is in the patronage of the Earl of Chesterfield and consists of a nave, aisles, south porch, chancel, and has a tower and spire at the west end.

The tower, which dates from around the middle of the fourteenth century, has a broach spire with gabled lucarnes and is a classic example of the Decorated period. The emblems of the four Evangelists – the Lion, the Man, the Ox, and the Eagle – can be seen at the four corners of the tower at the base of the spire. Also of the same period as the tower and spire is the archway into the chancel and the arcade of three pointed arches supported on octagonal pillars between the north aisle and the nave. The south arcade, although similar, is of a rather earlier date and is supported on circular columns.

In about 1450, during the Perpendicular period, there were extensive alterations made to the church. Pairs of pointed, two-light clerestory windows, eight windows on each side, were inserted into the raised walls above the nave arcades, and a square-headed, two-light window was placed over the chancel arch.

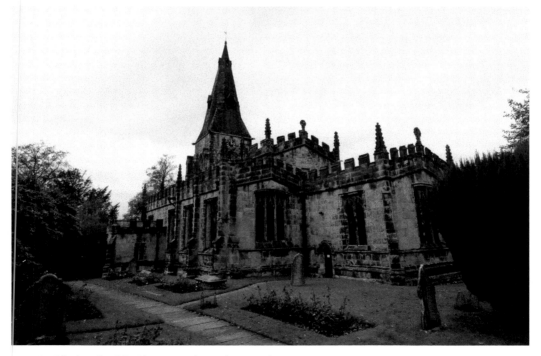

Parish church of St Clement and St John, Horsley.

Priest's entrance, Horsley parish church.

When the chancel itself was rebuilt, it was lighted with Perpendicular windows; and similarly, the aisles were lighted with square-headed traceried windows of the same style. The chancel, nave, and south aisle have battlements and pinnacles, and the south porch is also embattled. There are some interesting and far-protruding gargoyles on the south side of the church.

Following the alterations of the fifteenth century, Kerry and Allen of Smalley completely restored and refurbished the church at a considerable cost. The work, carried out between 1858 and 1860, included renewing the top of the spire, re-roofing, re-seating and re-paving. Unfortunately, while an insecure pillar at the west end of the south clerestory was being examined, it failed causing the whole of that side of the church to fall, demolishing most of the pews and the gallery that ran along the length of the west end of the church. The church eventually reopened on 11 September 1860.

Further reordering was carried out in 1928 when a carved oak reredos was installed and later, in 1935, similarly styled choir stalls were added.

The font is octagonal in shape and from the fifteenth-century Perpendicular period. The significance of the eight sides relates to the writings of St Ambrose who suggested that fonts are octagonal 'because on the eighth day, by rising, Christ loosens the bondage of death and receives the dead from their graves'.

Broached spire at Horsley parish church.

The canopies of the three sedilia in the south wall of the chancel have cinquefoil heads. There is a small piscina at the east end of the south aisle and a double one at the same end of the north aisle.

There are a number of black slate and white marble wall memorials around the church. Of especial note is the memorial to William Brooks and his wife.

The church has a number of interesting stained-glass windows, but of particular note are the two central windows of the north aisle by Robert Anning Bell, which were commissioned in the early part of the twentieth century. Also, there are fragments of fourteenth century glass in one of south aisle windows.

Nicholson and Lord of Walsall built the pipe organ that dates from 1895.

There is a ring of six bells in the tower, although originally there were only four. Parish legend eludes that at the time of the rebuilding of St Alkmund's in Derby, the then vicar of St Clement and St John's entered into negotiations with St Alkmund's officials with a view to selling them the prized tenor bell. However, when news of the proposed sale came to the attention of the church wardens, the sale was promptly stopped. The original four bells date from the beginning of the seventeenth century.

 I. 'Ihs be oure sped.' Mark of Henry Oldfield.
 II. 'I sweetly toling men do call to taste on meats that feeds the soule, 1620.' Mark of George Oldfield.
 III. 'God save our King, John Beardsley, 1660.' Mark of George Oldfield.
 IV. 'Ihc Gloria in excelsis Deo, Anno Dni 1603.' The Heathcote mark, 'G. H.,' above a fylfot cross.

Local records would suggest that the parish of Horsley has the dubious honour of being the birthplace of Dick Turpin. It is known that a John Tyrpin was churchwarden in 1599, and the name continues in the registers for many years following.

Location: **DE21 5BF**

14. St Michael and All Angels', Hathersage

Ralph FitzHubert held the manor of Hathersage at the time of the Domesday Survey, but it is believed that the present building dates from 1381. However, it is known that there had been a church on this site for at least 200 years before that time, and that there was a vicar at Hathersage as early as 1281.

The church, which is dedicated to St Michael and All Angels, has a chancel with north aisle or chapel, a nave with side aisles, a south porch and an embattled tower surmounted by a lofty spire.

Much of the building is of the Decorated school of architecture dating from the first half of the fourteenth century, as are most of the stained-glass windows, with the exception of the glass of the north chancel chapel and the west window of the tower, which are examples of the Perpendicular style.

During 1851–52, in collaboration with the then vicar, Revd H. Cottingham, and the architectural practice of Joseph Butterworth, the church was completely

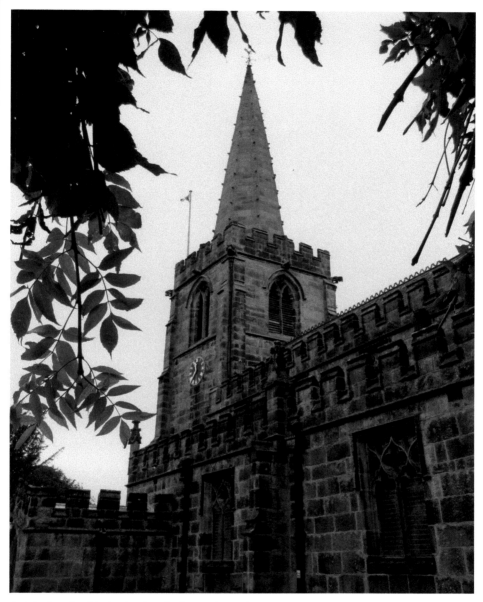

Parish church of St Michael and All Angels, Hathersage.

restored. Most of the external masonry was renewed, although Butterworth managed to retain much the original character of the building. *The Derby Mercury* reported that the Bishop of Lichfield would be the officiant at the reopening, which was to be held on Thursday 15 April 1852, and that there would be two further services that would be held on the following Sunday, and that these too would be in aid of church funds.

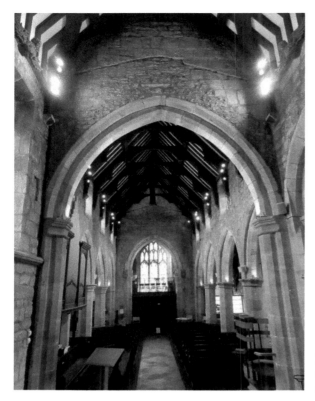

Looking towards the west window – St Michael and All Angels, Hathersage.

Prominently displayed on several of the tombs in the sanctuary are brasses of members of the Eyre family. On the north side of the chancel, shielded under an elaborate canopy, there is an altar tomb with brass effigies of Robert Eyre of Hope, who fought at the Battle of Agincourt, his wife, Joan, and their fourteen children. There are also brasses on the other side of the sanctuary of Ralph Eyre of Offerton Hall and his wife, Elizabeth, and also of Sir Arthur Eyre of Padley and his first wife, Margaret. Other brasses commemorating the Eyre family date through the fifteenth, sixteenth and seventeenth centuries. Another significant brass to be found in the chancel commemorates Revd John Le Cornu, for fifty years vicar of the parish, who died in 1844.

Surmounting the tower is an octagonal spire. The bell tower has a ring of six bells, duly inscribed:

- I. 'E mero motu hie habitantium,' in Roman capitals.
- II. 'Ex dono Tho: Bagshaw Arm: Cujus insignia,' followed by the family crest, an arm couped at the elbow, and erect, holding a bugle horn.
- III. 'Gloria in exselsis Deo, 1659'; crest of Eyre, a human leg armed couped at the thigh spurred, between the initials 'R. E.'; followed by the ornate initials W.I.S.
- IV. 'Nos ab ruina salvet Virgo Katerina,' in old English letters, with ornate Lombardic initials.

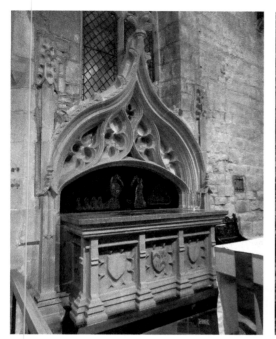

Above left: Altar tomb of Robert Eyre of Hope, his wife Joan, and their fourteen children.

Above right: Grave of Little John.

> V. 'Tuo nomine dulcidina vocis cantabo, C. W., G. E. 1657.' Below the date are the initials W. I. S., and on each side are the initials R. E. below the Eyre crest.
>
> VI. 'Ihc. Gloria in excelsis Deo, 1617,' followed by the founder's initials P. H.

There is also a fifteenth-century sanctus bell, which is inscribed with a prayer for Robert Eyre and Joan Padley.

As a direct result of the considerable damage caused by the gale of December 1872, much of the top of the spire was renewed.

The octagonal font at the west end of the church dates from the Perpendicular period.

A small piscina is on the south side of the chancel together with three sedilia.

There are some remains of old stained glass to be found in the upper tracery of one of the windows of the north aisle. The fragments, originally to be found in Dale Abbey, include likenesses of an owl, a griffin, a seated ape and an eagle's head and wings; Miss Wright, of Brookfield presented them to Revd H. Cottingham. In 1949 a new east window was inserted at St Michael's, having been rescued from the church of St John and St James at Derwent, before the church itself was subsumed when the valley was flooded in order to create the Derwent Dam.

The tradition of displaying a 'Maiden's Garland' – proclaiming virginity and innocence – at the funeral of an unmarried woman or girl was an ancient custom,

The new east window
rescued from the church
of St John and St James at
Derwent, before the valley
was flooded.

dating, it is believed, from the time of the Romans and continued in Hathersage church even as late as 1818, when remnants of ancient funeral garlands could still be seen hanging inside the church, but these have long since disappeared.

It is believed that Little John – Robin Hood's right-hand man – was born in Hathersage, and local legend asserts that when he died in his cottage, which was near to the church, he was buried in the churchyard. However, other than long-standing anecdotal evidence, there is no definitive verification of this claim. The grave was opened in 1782 under the direction of Captain James Shuttleworth and a 32-inch thigh bone was discovered, suggesting that the complete skeleton would be approximately 7 feet in length. The bone was later replaced in the grave.

It has been suggested that Little John's cap, his longbow and some of his arrows were displayed in the church, but there has been some divergence of opinion as to whether it was the church or Hathersage Hall where the artefacts were held. Early in the nineteenth century the artefacts were removed to Cannon Hall near Barnsley.

Little John's grave can be found in the graveyard lying under a yew tree to the south-west of the church.

Location: S32 1AJ

15. St Mary and All Saints', Chesterfield

The Romans, who had a permanent settlement in Chesterfield, might have brought Christianity to the area. Indeed, it is believed that there has been a church in Chesterfield since the seventh century with some church records dating from Norman times. The oldest pillars in the church stand on the east side. Then, because of the prosperity of the town during the reign of King John a new, grander, church was built, with the chancel and crossing being completed by 1234. By the early fourteenth century the south transept and the tower together with its spire had been added. The structure was completed around 1360.

The parish church of Chesterfield, dedicated to St Mary and All Saints, is the largest church in Derbyshire. The church follows the Early English tradition, although there are elements of Decorated Gothic and Perpendicular Gothic featured in the architecture. The church has a cruciform plan with a nave, aisles, north and south transepts and a chancel surrounded by four guild chapels. One of the earliest chapels in the church was the chapel for the Guild of our Lady. Religious turmoil in the sixteenth century ultimately led to the chapel being renamed as the Foljambe chapel. The alabaster tombs of the Foljambes can still be seen in the chapel.

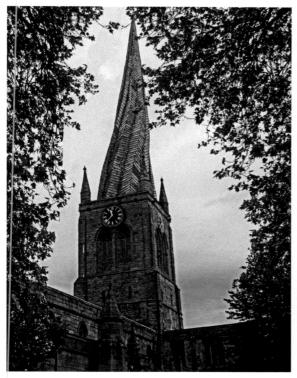 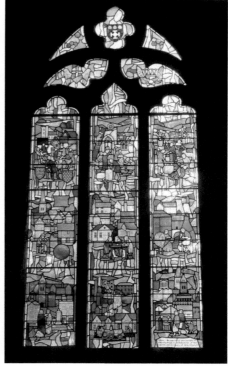

Above left: The parish church of St Mary and All Saints, Chesterfield.

Above right: The stained-glass window celebrating the 750th anniversary of the church in 1984.

The church spire twists some 45 degrees and leans approximately 9½ feet from its true centre. Historians originally attributed the reason for the spire's misalignment to the fact that, because of the loss of so many skilled craftsmen during the time of the Black Death, inexperienced workers had failed to use sufficient cross bracing when constructing the spire, together with excessive use of unseasoned timber. This reasoning was later discredited and a more plausible explanation forwarded. During the original construction of the spire, wood shingles were placed over the spire's wooden framework. When the shingles eventually rotted they were replaced by upwards of 33 tonnes of lead tiles – lead being readily available in the area at that time. It is now widely accepted that because the spire's unseasoned timber framework had not been designed to carry such a great load and, because of the effect of the sun on the spire, there was a differential rate of expansion and contraction on different sides of the spire, which, ultimately, caused the twisting.

Restorations and remodelling of the church have been carried out over the years. In 1769 the north transept was rebuilt and later, in 1843, further restoration work was carried out under the direction of George Gilbert Scott, when a new ceiling and stained-glass east window were commissioned. Also, Samuel Johnson donated a new font and the refurbished church, having been closed for nine months, was reopened on 9 May 1843.

Disaster struck the church on 11 March 1861 when the spire was struck by lightning, which, ultimately, caused a fire to start in a beam next to the wooden roof of the chancel. The fire was discovered by the Sexton on his nightly round.

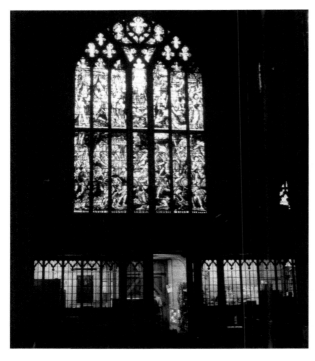

The west window, Chesterfield parish church.

 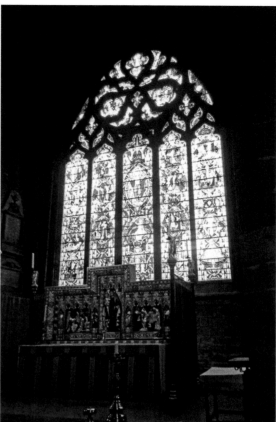

Above left: The world-famous crooked spire.

Above right: The east window, Chesterfield parish church.

In 1700 another bell was added to the six already housed in the tower and, in later years, an eighth was added by public subscription. The old peal was taken down in 1819 and replaced with a peal of ten bells. These bells were then recast in 1947 by the Whitechapel Bell Foundry in London. There is an eleventh bell at Chesterfield church, known as the 'Shriving' or 'Curfew Bell'. In essence, the bell was used during the period when Chesterfield housed a number of Napoleonic army and navy officers who were on parole in the town. The ringing of the bell signalled that it was time for them to return to the confines of the town.

The high altar reredos, designed by Temple Lushington Moore, was installed in 1898.

The bicentenary rebuild of the Snetzler organ was completed in 1958, but, three years later on 22 December 1961, there was another serious fire, which resulted in many of the interior fittings in the church being destroyed including irreparable damage to the organ. The Lewis organ from the City Hall, Glasgow, was purchased to replace the lost Snetzler.

Dating from 1890, the west window is by Hardman. In 1984 a new stained-glass window, the Anniversary Window, was presented to the church by the townspeople of Chesterfield to celebrate the church's 750th anniversary.

Location: S40 1XJ

16. ST ALKMUND'S, DUFFIELD

When the Domesday Survey for Derbyshire was completed in 1086, reference was made to the fact that there was a church, a priest and two mills on the manor of Duffield. Henry de Ferrers, the founder of Tutbury priory, had been given the manor, together with another 113 manors in Derbyshire, by the Conqueror. Although the original structure was, in all probability, built in Saxon times, no trace can be seen in today's church. The church does however retain its dedication to the Saxon saint, St Alkmund, which might suggest a substantial building. The church, when originally built in the twelfth century, only comprised a nave and chancel. The corbel table, which features ten grotesque heads at the top of what was, in Norman times, the outside of the north wall of the chancel, is currently the inside of the north chapel and is used as a vestry. The present church has a nave, south aisle and porch, a north aisle with a north transept, and a chancel with a north side chapel or aisle, which was previously known as 'the vicar's chancel'. There is a tall, embattled tower at the west end of the church that is surmounted by a spire.

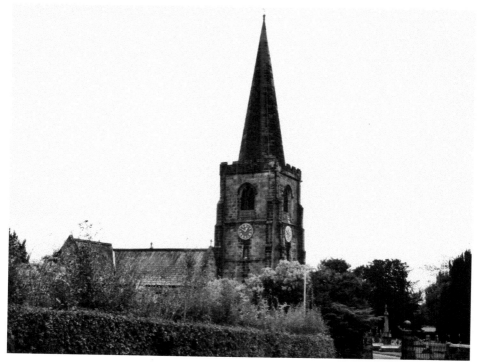

Parish church of St Alkmund, Duffield.

Tower and spire of St Alkmund's parish church, Duffield.

In former times, the parish of Duffield was extensive and included the townships of Hazelwood, Holbrook, Makeney, Milford, Shottle, and Windley; together with the chapelries of Belper, Heage, and Turnditch.

The three-light window in the north wall of the north transept together with a similar window at the east end of the chancel aisle and the arch from the nave into the chancel are early examples of the Decorated style and can be dated to the end of the thirteenth or of the beginning of the fourteenth century.

The windows in the chancel are fine examples of the late nineteenth-century work of Charles Eamer Kempe, as are windows in All Saints, Bakewell, and St Oswald's, Ashbourne. The story of the Crucifixion is depicted in the south wall and starts with the scene in the Garden of Gethsemane and continues through to the trial before Pilate and, ultimately, the Way of the Cross. The east window shows Christ crucified with John the Baptist and His mother Mary on His right and John the disciple whom He loved and Mary Magdalene on His left.

There were some relatively minor repairs carried out towards the end of the seventeenth century, but further major restoration was carried out in 1847 when the roofs of the north and south aisles were raised to a higher pitch, although the nave and chancel retained their flat roofs which were of the Perpendicular period. Both the east and west windows in the south aisle follow the Decorated style.

Dating from 1536, the table tomb of Sir Roger Mynors and his lady are to be found in the north chapel. Just above the tomb is a squint, which, like a number of other churches in the county of a similar period, gave worshippers seated in the chapel an uninterrupted view of the high altar in the chancel.

During later renovations, which were carried out in 1897, two incised stones showing the Eagle and Lion were found built into the west wall of the south aisle. It is thought that they originally formed part of an old Norman font. The style of the octagon font at the west end of the church would suggest that it dates from about 1662, when fonts that had been destroyed by the Puritans were being restored to churches.

A monument to Anthony Bradshaw, his two wives and twenty children was erected by himself in 1600, although before his death in 1614, he fathered another three children, the second one being christened Penultima. The Bradshaw memorial is located on the site of a former altar in St Thomas's chapel. The chapel is now known as the Bradshaw chapel.

It is recorded that by 1720 St Alkmund's had a peal of four bells, which was subsequently augmented to six. By 1887 the peal numbered eight bells, which was later increased to ten by Sir Arthur Heywood, a keen campanologist, churchwarden and sidesman at the church. The bells were recast in 1933.

A new organ, built by Cousans Organs of Coalville, was installed in 1972 with the console placed at the front of the south aisle and the pipework in front of the west window.

Built in the church grounds, the new parish hall was completed in 1992.

The front of the nave was reordered in 1997. By removing the front rows of pews it was possible to build a dais in front of the chancel arch. Another dais was

created in the south aisle. More recently an oak Communion table was given to the church and is used at the main Communion services.

Location: **DE56 4BA**

17. St Mary and St Barlok's, Norbury

The manor of Norbury (Nordberie or Nortberie) was just one of the many manors given to Henry de Ferrers by William the Conqueror. At the time of Domesday Survey the manor is recorded as having a church and a priest. When founding the priory of Tutbury, Henry de Ferrers gave the church and its tithes to the priory's monks. The manor was conveyed to William FitzHerbert in 1125. The FitzHerbert family were lords of the manor and patrons of the church for over 500 years until their Roman Catholic faith required them to relinquish the position in the mid-sixteenth century.

The first church on the site dates from Anglo-Saxon times, and the second is a late Norman church, being built around 1179 by John FitzHerbert. The building of the current church, dedicated to St Mary and St Barlok (Barlock), commenced in 1295. The church has an unusually large chancel – almost 50 feet in length – and, being built towards the end of the Decorated period, is the oldest part of the church. Construction continued over the next two centuries with the building of

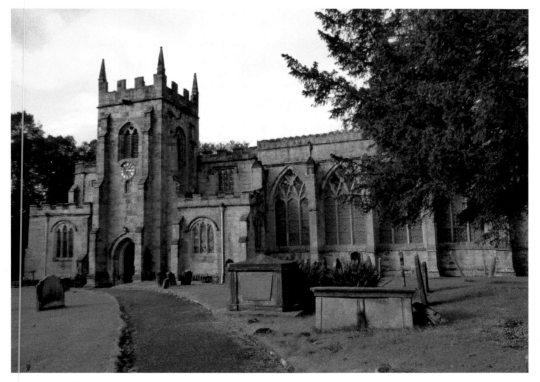

Parish church of St Mary and St Barlok, Norbury.

Left: Priest's entrance, Norbury Church.

Below: The magnificent east window at St Mary and St Barlok, Norbury.

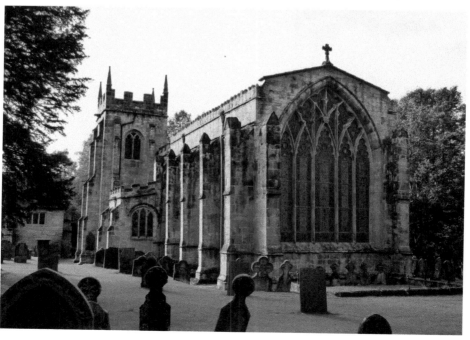

the south tower, nave and chapel east of the tower being attributed to Nicholas FitzHerbert, and either he or his son, Ralph, built the north aisle. The building of the south-west chapel is attributed to his grandson John FitzHerbert. The FitzHerbert family also commissioned much of the stained glass in the church. Many members of the family are buried within the church, marked by brass plaques and alabaster tombs. The tombs, located in the chancel, are among the finest in the country. The first tomb chest is a Chellaston alabaster effigy showing exquisite detail in the figure of Nicholas FitzHerbert, while the second depicts Ralph FitzHerbert with his wife, Elizabeth Marshall and all of their children. The tombs, which are both well preserved, are fine examples of medieval craftsmanship.

Two Saxon cross shafts have been brought into the body of the church to preserve them from weathering. They are perhaps the oldest relics in the church, dating it is thought from the tenth century. The font is also one of the oldest features in the church, dating from the beginning of the thirteenth century; it stands against the central pillar of the aisle. The bowl is simple and rests on a carved base of clustered shafts. There is also a rare fourteenth-century double piscina in the chancel.

By the mid-nineteenth century it was noted that the church was in a poor state of repair and in need of restoration. The work was extensive and included replacing the old, closed pews with open stalls. Further restoration was necessary at the end of the century. The main building contractor for the restoration was William Gould of Tutbury under the architectural guidance of Naylor and Sale of Derby. The Clowes family paid for the restoration work on both occasions. The culmination of the restoration was celebrated when the Bishop of Southwell reopened the church in February 1900.

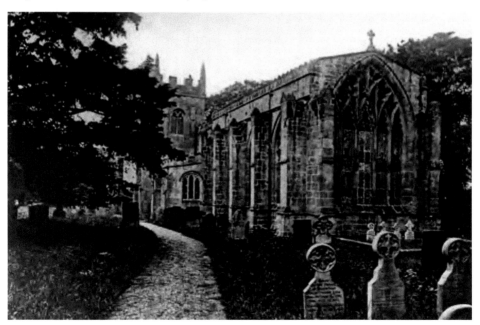

Early image of St Mary and St Barlok, Norbury.

The three bells in the tower were all made by different founders: the first bell, dating from 1500, was foundered by Richard Mellours (Mellers) of Nottingham and bears the inscription 'Sonat hec celis dulcissima vox gabrielis'; the second bell was foundered by Henry Oldfield, also from Nottingham, and bears the inscription 'Jhesus be our speed, 1589'; and the third bell was foundered by John Halton and bears the inscription 'Gloria in excelsis, 1739'.

A pipe organ was built and installed by Charles Lloyd of Nottingham in 1890.

There are eight rare Grizaille stained-glass windows in the chancel: four on the south side and four on the north. Dating from 1306, they are thought to be the oldest in the country. There is a unique effect created when light shines through the windows and, for this reason, the chancel is often referred to as a 'lantern in stone'. The windows were cleaned and restored by Holy Well Glass of Wells in 2004; much of the work was funded by English Heritage.

Location: **DE6 2EQ**

18. ALL SAINTS', MACKWORTH

The manor of Markeaton, held by Hugh, Earl of Chester, had a priest and a church at the time of the Domesday Survey; at that time Mackworth and Allestree were considered to be berewicks. However, there has been a church at Mackworth since the beginning of the twelfth century, although the present building dates from the early fourteenth century with significant alterations in the fifteenth century and further restoration in the nineteenth century – notably, the addition of the organ

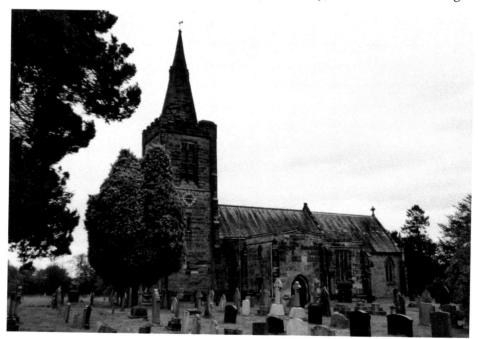

All Saints' Church, Mackworth.

chamber and vestry. Dedicated to All Saints, the church has a chancel, which incorporates a north vestry and organ chamber; a south porch with parvise; a nave, having north and south aisles and an embattled tower at the west end of the church, which is surmounted by a recessed octagonal spire. The church, together with the tower and spire, was completely rebuilt towards the end of the Decorated period, circa 1370–80. The buttresses, at the east end of the church, are crowned with crocketed pinnacles.

Divided by a chamfered string course, the west tower has been built in two unequal stages, the ground stage has arrow slits beneath the string course on the

Tower and steeple, All Saints', Mackworth.

west and north sides, with a third on the south side being concealed by the church clock – a very rare occurrence in church architecture and possibly incorporated for defensive reasons. The bell stage of the tower is lighted by large square-headed windows of two lights on all four sides. The lozenge clock face to south dates from 1872. The recessed spire has a single tier of lucarnes.

There are three bells in the tower:

 I. 'God save the King, 1662,' with the bell-mark of George Oldfield.
 II. 'Jhesus be our speed, 1612,' with the bell-mark of Henry Oldfield.
 III. 'God save His Church, 1616,' with the bell-mark of Henry Oldfield.

Separating the nave from the aisles there are three arches on either side, supported by octagonal pillars and half-pillars bonded into the walls (responds). There is no regular archway into the tower from the nave, but a large, pointed doorway. Towards the latter half of the fifteenth century the east and west windows of the south aisle were renewed in the Perpendicular style.

Access to the chamber, or parvise, over the porch was gained by a circular staircase within the wall in the north-west angle. The room, which previously had a fireplace and chimney in the south wall – both of which were removed at the time of the church restoration in 1851 – served as a dormer for one of the chaplains or sacristan. Through the two 'squints' located in this space, watch could be kept over many valuables that were lodged in the side altars.

During the church restoration of 1851 a piscina in a small trefoiled niche was uncovered at the east end of the south aisle. At the time of the restoration of the church, the basin font was replaced by an octagonal font of Caen stone in the Decorated style. The east window has four lights, having two trefoils and a quatrefoil in the upper tracery. The tracery of this window was completely renewed during the general restoration of the church in 1851, but is an exact replica of the earlier window. During this time a west gallery in the nave was abolished, as were the old pews, and the organ chamber and vestry on the north side were added. Following restoration, All Saints was reopened by the Bishop of Lichfield on Thursday 13 November 1851.

There are many memorials to the Mundy family within the church, which includes in the south aisle a raised monumental tomb of alabaster that commemorates Edward Mundy, who died in 1607, and his wife Jane – their children are shown along the front of the chest. Edward Mundy's effigy shows him in a long gown with ruffs around the neck and wrists; a pulpit of alabaster and marble, designed in the Florentine style, which was presented by Mrs F. N. Mundy, in 1876; the Derbyshire alabaster reredos with inlaid stones, which was added in 1878 by Mrs William Mundy in memory of her husband, was designed by James Kellaway Colling of London; Francis Noel Clarke Mundy is commemorated in the stained east window, and the canopy over the vestry door was erected in memory of Mrs William Mundy in 1889. There are also wall tablets on the south side in marble and alabaster commemorating the lives of Francis Noel Mundy, who died on 10 January 1903, and Emily Maria Georgina Mundy, who died on 6 August 1929.

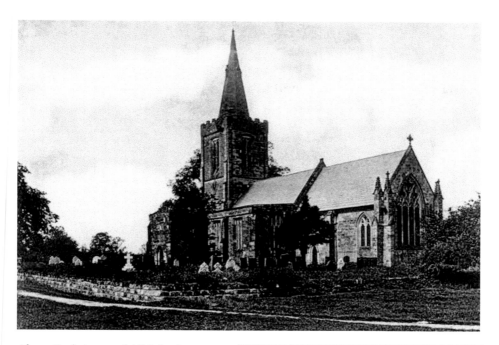

Above: Early image of All Saints',
Mackworth.

Right: Sketch of chancel doorway, All
Saints', Mackworth.

Graveyard at All Saints', Mackworth.

There is an arched sepulchral recess in the south aisle. The alabaster slab is thought to be the tomb of Thomas Touchet, who was rector of the parish from 1381 to 1409.

There is an arched recess against the north wall with a projecting canopy above it; known as the 'Abbot's seat', it was, in all probability, the official seat of the abbots of Darley.

In 1870 Lloyd and Dudgeon of Nottingham built and installed the pipe organ.

The pulpit, of Derbyshire alabaster and green Irish marble, was added in 1896. In 1903 Charles Lomas of Derby designed and made, from a single block, the carved Chellaston alabaster lectern.

Said to be modelled on a balustrade in Rome, the Communion rails date from 1893, and are manufactured from white alabaster and inlaid with locally sourced Blue John and other stones.

Location: **DE22 4NG**

19. St James', Smisby

A chapel was first built in Smisby (Smithsby) sometime in 1068 by monks from Repton Priory. This original chapel now forms part of the south aisle of the church. After his death, the widow of William Shepy, Joanne Comyn, became the owner of Smisby and added the nave and chancel to the original building early in the fourteenth century. The present church was, in all probability, built on the same site – the oldest remaining part dating from the thirteenth century. In 1271

the chapel at Smisby was designated as being a chapel of ease, one of seven others that paid allegiance to the mother church at Repton. Rather than having to travel to the parish church, villagers could worship at the chapel. Augustinian canons from the priory lead all the chapel services.

Typical in the style of the time, the church of St James has a nave, south aisle, chancel, and tower at the west end. There are three pointed arches that separate the aisle from the nave. When it was first built the church was dedicated to St Wystan of Repton, but the dedication was changed sometime later to that of St James.

There was significant restoration work carried out between August 1895 and May 1896. During the restoration much of the plaster was removed from the walls, the internal stonework was repaired and repointed and the caps and bases of the piers were cleaned and renovated. The old box pews were replaced and the floor was relaid with wood blocks. Also, repairs were made to the nave, aisle tower, porch and the 'squint' was also modified at this time, giving a better view of the altar from the south aisle. The fourteenth-century octagonal font, which was originally under the first arch, was moved to its present position and placed on a new base to match its design. At the same time the floor was raised so that stone heating channels could be put under the floor. A new altar table, pulpit, lectern and choir seating completed the restoration. The church was reopened on 22 May 1896.

One of the more interesting features within the church is a large alabaster monument that can be found against the west wall of the aisle. On the memorial

Parish church of St James, Smisby.

Graveyard at St James, Smisby.

itself there is the figure of a lady sculptured in slight relief; she is wearing a headdress and there are two small dogs at her feet.

The organ is located in a space at the foot of the tower and was designed, built and installed by John Housley Adkins of Derby in 1954. The nearby side altar is dedicated to Dr Mark Baker, the village's doctor; he scarified his life in trying to save two men trapped down a well.

There is an Early English lancet window at the east end of the south aisle, whereas the three-light east window of the chancel is an example of the Decorated period. The tower at the west end of the church is of the Perpendicular style, having an embattled parapet and four pinnacles.

St James' Church has two bells, which are housed in the second-floor bell chamber in the tower. The older bell, foundered by Hugh Watts of Leicester, bears the inscription 'God save the King 1617' and the second bell was foundered by George Oldfield of Nottingham and bears the inscription, 'God save King Charles the second 1662'. Because of wear over the years, the bells were taken out of commission in 2001. Then, in 2007, they were removed to the bell founders Taylors Eayre & Smith of Loughborough where new clappers were fitted. On their return, the bells were mounted on new headstocks and refitted for swing chiming on new bearings.

Made in 1805 by a member of the REA family of clockmakers based at Walton on Trent, the turret clock is thought to be the only surviving example of its kind. A full restoration of the clock's mechanism was completed at the turn of the millennium.

Location: **LE65 2UA**

20. ST ANDREW'S, CUBLEY

Cubley (Cobelei) was held by Ralph under Henry de Ferrers at the time of the Domesday Survey. Under the title of 'The Lands of Henry de Ferrers' it states:

> In Cubley Siward had two carucates of land to the geld. There is land for two ploughs. There are now two ploughs in demesne and four villans and four bordars and one slave having one plough. There is a priest and a church and one mill rendering 12 pence and eight acres of meadow and woodland pasture one league long and one league broad. TRE [Tempore Regis Edwardi; meaning, in the time of King Edward before the Battle of Hastings] worth 100 shillings now 40 shillings. Ralph holds it.

The church of St Andrew, Cubley, is characterised by its chancel, nave, south aisle, and north and west porches. The church has an embattled tower at the west end that houses four bells.

Towards the end of the twelfth century the Norman chancel was replaced by one of the Early English style dating from the latter part of the twelfth century. On the south side of the chancel, nearest to the east end, are two lancet windows filled with old glass; one shows a figure of St Catherine with her wheel of martyrdom, and the other is of a kneeling bearded saint. The glass, which dates from the

Parish church of
St Andrew, Cubley.

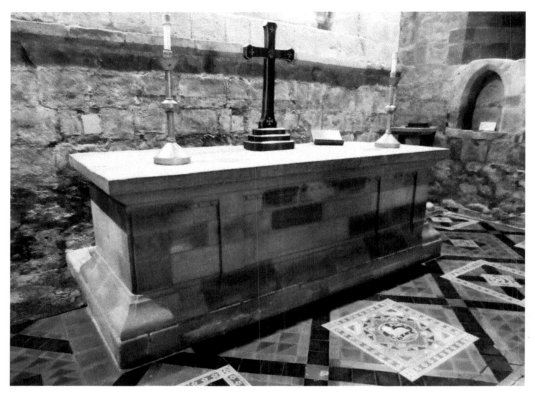

The original medieval stone altar, which, in all probability, was fashioned to hold some of the relics of St Andrew.

fourteenth century, has been moved from the east window. The third lancet shows an image of St Andrew. There are two lancets on the opposite side, which also have a large number of fragments of old glass. Also in the chancel there is a stained east window inserted in 1874 by the children of L. C. Humfrey and his wife Emma.

Three semicircular arches supported by two round pillars divide the nave from the aisle, and are of the Norman period – the prevailing architectural style when the church was built. The shape of the circular font at the west end of the aisle would suggest that this too is from the Norman period.

The chancel has been restored on two occasions: in 1845 and again in 1874. The church was completely re-seated in 1885.

The west tower was originally built in the reign of Henry VIII and follows the late Perpendicular style of architecture, having strong vertical lines, large windows and elaborate tracery. The west door has a pointed three-light window directly above it. Three quatrefoil openings light the second stage of the tower on the west, south and north sides. Similarly, the bell chamber has four two-light windows of the traditional Perpendicular pattern. The summit has an embattled parapet and four pinnacles at the angles. The tower was restored in 1874. A number of coats of arms of the Montgomery family and its various alliances are displayed on the exterior.

 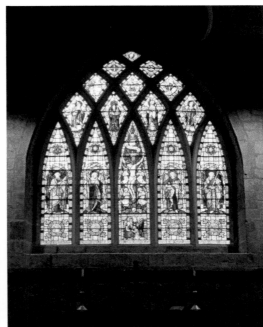

Above left: The circular font, dating from the Norman period.

Above right: East window, inserted in 1874 by the children of L. C. Humfrey and his wife Emma.

There are several other monuments to the Montgomery family in the church including a raised alabaster tomb to Sir Nicholas Montgomery on the north side of the church, dated 27 March 1435, although much of the inscription has now been obliterated. The recumbent effigy of a knight in plate armour lies on the top. There are figures of angels holding shields around the sides of the tomb. And, within an arch on the south side of the church there are the remains of a marble tomb, thought to be the tomb of the third Sir Nicholas Montgomery and his wife Joan Haddon.

There is a ring of four bells in the tower. The inscriptions on the bells are as follows:

 I. 'God Save His Church, 1661,' and the founder's mark of George Oldfield.
 II. 'Barbara o. p. n.'
 III. 'See Andrea o. p. n.'
 IV. 'God Save His Church, I. H., H. B., Wardens, 1688.'

The inscriptions 'o. p. n.' on the second and third bells are invocations to St Barbara and SaStint Andrew – the patron saints of the church – and are taken from the Latin *ora pro nobis*, meaning 'pray for us'.

The north wall, thought to be built from remains of building material from an earlier Saxon church that occupied the same site.

In 1896 the organ builders Conacher and Co. of Huddersfield built and installed the pipe organ at St Andrew's.

The church was restored between 1872 and 1874 under the direction of the noted English architect James Piers St Aubyn. The south porch was added in 1909.

Location: **DE6 2EY**

21. ST MARY'S, CRICH

Crich is not mentioned in the Domesday Survey, although at that time Crich was the principal residence of Ralph FitzHubert, being just one of the nineteen manors that he held in Derbyshire. Later, his son, Ralph FitzRalph, 1st Baron of Crich, gave the church at Crich to Darley Abbey, when the canons were removed from Derby to found the abbey at Darley. A vicarage was formally ordained at Crich during the episcopate of Alexander Stavenby, 1224–40, and endowed with tithes of lambs and wool.

Following the years when the Black Death was extant in the region, a number of curious superstitions and edicts appeared in the church's calendar, such as if anyone lets blood on 11 April in the left arm, he will not lose his eyesight for that year, but if he lets blood on the 3rd he will be saved for that year from headache and *extasim Anglice Swymes*; that four days of May are very dangerous – the 7th, 15th, 16th, and 20th; that if blood is let on the 7th of the Kalends of August, the

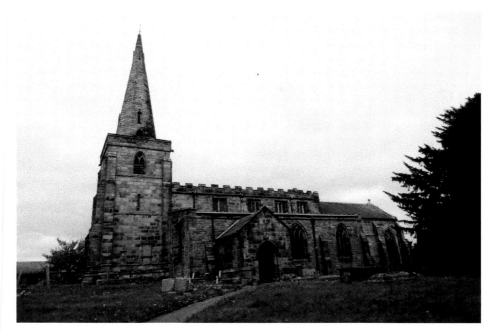

Parish church of St Mary, Crich.

patient will die on the third day after; that no one who is bled on 17 September need fear having paralysis, dropsy, or epilepsy for that year; and that if anyone strikes either man or beast on 26 March, 25 July, or 8 December, he will assuredly die on the third day after, *et hoc probatum est*.

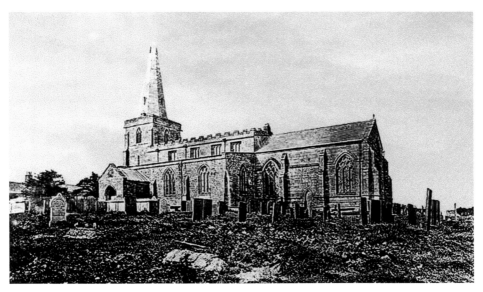

Early image of St Mary, Crich.

The church at Crich is dedicated to St Mary, although Kelly's Post Office Directory of 1855 would suggest that at that time it was dedicated to St Michael. The church has a nave, side aisles and south porch, chancel with north vestry, and a tower and spire at the west end. Much remains of the church that was first erected here by Ralph FitzRalph in the reign of Stephen (1135–54). The nave is separated from the aisles on each side by three plain and round Norman arches. At the west end of the south aisle is the Norman font, which is circular and surrounded with a moulding of the cable pattern.

It would appear that the church was thoroughly renovated and rebuilt sometime during the fourteenth century at the time of the Decorated style. The chancel, vestry, tower, spire, and exterior walls of the aisles date from that period. The windows in the south aisle would also indicate that it was rebuilt at that time. The tower has a moulded parapet, and the spire is octagonal with two tiers of lights. The weather moulding of the high pitch roof of the Decorated period can be seen on the west side of the tower. The porch has a plain doorway with square-headed windows of two lights, all dating from the Perpendicular period.

In the north chancel wall there is a recess that, similar to many other churches in the region, shows there was originally a squint going right through the wall and into the vestry, which would have given the sacristan or other persons the ability to see the high altar from that vantage point. On occasions the aperture was used by the priest to hear confessions, with the penitent being in the vestry.

Chancel door, St Mary, Crich.

Wall tablet erected in memory Ann Harrison.

Up until 1721 there were only four bells in the tower, but by 1879 St Mary's had a ring of five bells:

I. 'John Dod, John Feepound C: Wardens, MDCCXXI'.
II. 'Feare God honor the King, 1671', and the bell mark of George Oldfield.
III. 'I. Saxton, G. Silvester, Churchwardens. I. Goddard, Minister, 1771'.
IV. 'Hec Campana sacra fiat Trinitate beata, 1616', in Lombardic capitals, highly decorated.
V. 'All men that heare my mornfull sound, Repent before you lye in ground. 1626'.

Above the bells in the tower is the old sanctus bell, or the parson's bell, as it was called, which at one time used to hang over the east gable of the nave. Sometime after the end of the First World War a further two bells were added, making a peal of eight bells.

The bells were recast in 1928 and a service for 'Dedication of Bells' was held on Saturday 13 October 1928.

A celebratory peal of Grandsire Triples was made on Saturday 26 January 1929, requiring 5,040 changes and taking a total of 2 hours and 59 minutes to complete. This was the first peal on eight bells since recasting and augmentation.

Location: **DE4 5DJ**

22. St Peter's, Edensor

No reference to a church on the manor of Edensor is made in the Domesday Survey, although it is known that a church in the Norman style of architecture was built shortly afterwards. The Domesday Book records that over 200 manors, including Edensor, were awarded to Henry de Ferrers by William the Conqueror. In John's reign the manor was held by Henry Fulcher. The earlier Saxon church, which was thought to serve Edensor, was replaced early in the Norman period. There is a written record, dating from the reign of King Stephen, which declares that Henry Fulcher gave the living to the Augustinian abbey of St Mary, Rocester, in Staffordshire. In return, the monks of the abbey volunteered to say prayers for the souls of Fulcher and his family. However, by the time of the Parliamentary Commissioners report of 1650, the living of Edensor, said to be worth £40, referred to the impropriator – the person to whom a benefice is granted as their property – as being the Earl of Devonshire.

The old church consisted of a nave, chancel, side aisles, south porch, and a square embattled tower at the west end. The architectural style of the old church was predominantly of the Perpendicular period, but the east window of the chancel, the window at the east end of the south aisle, and another near to the priest's door on the south side of the chancel, were all of the Decorated period. Inside the old church, the nave was divided from the side aisles by Norman pillars, which, in all probability, had originally been erected by Fulcher.

Sometime in the 1750s the 4th Duke of Devonshire had the parkland surrounding Chatsworth House remodelled by Capability Brown and, having

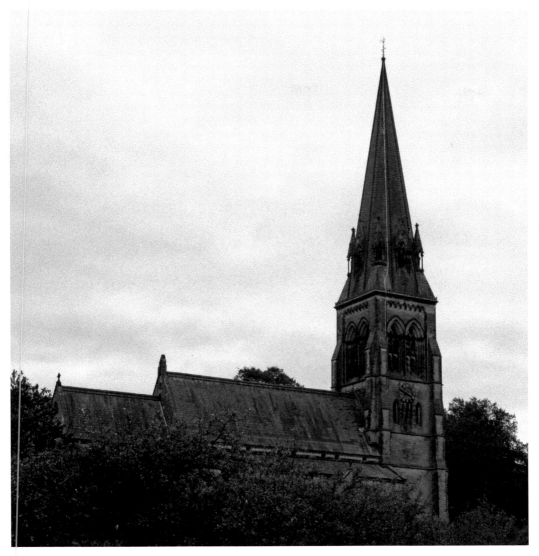

Parish church of St Peter's, Edensor.

spent a considerable amount of money in making the improvements, the duke decided that many of Edensor's cottages needed to be relocated as the village lay immediately adjacent to Chatsworth House itself, and many of the cottages were visible from the mansion. The duke considered that it would be more aesthetically pleasing to have the village moved some distance away. In the event, it fell to the 6th Duke to complete the process of dismantling the old village and building the present Edensor. Joseph Paxton, Chatsworth's head gardener, had oversight in the planning of the new village. Working closely with John Robertson, an architect from Derby, a plan for the relocated village evolved. The cottages were rebuilt

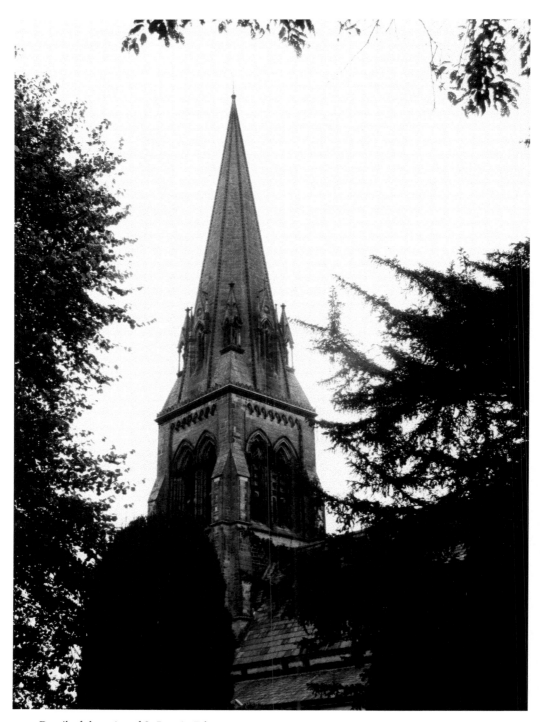

Detail of the spire of St Peter's, Edensor.

nearer to the fourteenth century parish church of St Peter. The rebuilding was completed by the early 1840s. Then, many years later, the 7th Duke commissioned the architect Sir George Gilbert Scott to design a new church in the Early English style. Scott's design, which was approved in September 1864, incorporated side aisles, nave, south porch, chancel and also managed to retain many of the original features, including the Cavendish chapel located on the south side of the chancel. The design also retained much of the stonework in the pillars and arches. At the west end of the building there is a tower surmounted by a broached spire. Scott also submitted designs for a number of the interior fittings, which included the pulpit, Communion rail, stalls, pews, the new font and the altar table. The rebuilding took almost five years to complete and the new church was consecrated in 1870.

Early sketch of Edensor Church.

On the west side of the Cavendish chapel there is the Cavendish Memorial, attributed to the Flemish sculptor Maximilian Colt and erected by 'Bess of Hardwick' and her husband, Sir William Cavendish, in honour of their two sons, Henry and William Cavendish (1st Earl of Devonshire) which, in the former church, served as a reredos to the chancel. The monument's central figure depicts Fame blowing a trumpet and holding two tablets, on which are inscribed lengthy epitaphs to their two sons.

There is also a memorial to Lord Charles Frederick Cavendish on the east wall of the Cavendish chapel. Lord Charles Frederick Cavendish, son of the 7th Duke of Devonshire, was murdered on 6 May 1882 in Phoenix Park, Dublin, within twelve hours of his landing in Ireland.

The tower in the old church had a peal of four bells, all cast by Thomas Hedderley of Nottingham in 1766. The bells were removed in 1867, three of them were recast and the fourth was used over at the Chatsworth stables. The present peal has six bells, all cast by the bell founder J. Taylor & Co. of Loughborough.

The east window, from the renowned stained-glass studio of Burlison and Grylls and dating from 1892, is a memorial to Lord Edward Cavendish. The west window by Hardman & Co. dates from 1879. The window depicts the virtues of a good steward and is in memory of John Cottingham who was steward to the 7th Duke of Devonshire. The chapel window, also by Hardman & Co., dates from 1882 and is in memory of Lord Frederick Charles Cavendish.

Bishop and Son of London built and installed the pipe organ, which dates from 1873.

The pulpit and font are both fashioned from Ashford marble and alabaster, mined on the duke's estates. A piscina and the old font were both transferred from the old church.

Most of the dukes of Devonshire and their families are buried in the churchyard as is Joseph Paxton and President John F. Kennedy's sister, Kathleen Kennedy, who was married to the 10th Duke's eldest son.

There is a nineteenth-century cross on a plinth of three stone steps to the left of the churchyard path. It is thought that the steps are from a preaching cross, which was outside of the earlier Saxon church that stood on the site. There is a sundial, fixed upon a portion of the shaft of the old cross. The gnomon is missing from the dial plate. There is no date on the sundial, but it is inscribed, 'Robt Meller, fecit'.

Location: **DE45 1PH**

23. All Saints', Kedleston

The manor of Kedleston was held by Gulbertus under Henry de Ferrers at the time of the Domesday Survey. The manor itself was recorded in the survey, although no reference was made to a church at that time. The earliest record of the church can be seen in the ancient Curzon deeds of 1198, when Richard de Curzon granted the villa of Kedleston, together with the advowson of the church, to Thomas, son of Thomas de Curzon. At that time the church's patronal saint was St Margaret, but then a book published in 1742 mistakenly referred to the church as being dedicated to All Saints. The church has been known as All Saints ever since, but the advowson of this rectory has remained, uninterruptedly, in the same family

from the beginning of the fourteenth century and through all of the subsequent centuries – the only recorded case in the whole county.

The cruciform plan of the sandstone church incorporates a nave with a north chapel, a chancel with a clerestory, north and south transepts, a north vestry and a central tower located over the crossing. For what is a relatively small parish church, this is a most unusual, if not unique, configuration. Much of the present church dates from its rebuilding in the thirteenth century. The upper part of the tower was rebuilt in the Perpendicular style towards the end of the fifteenth and the beginning of the sixteenth century. The tower is in two stages; the lower stage has two lancet windows, whereas the upper stage has two-light bell openings on each side. The tower's summit has an embattled parapet and crocketed pinnacles at the corners. The tower contains a single bell and has the following inscription: 'God Save His Church, 1880, T. Mears of London fecit.' A Georgian sundial was added to the east face in the early part of the eighteenth century.

The semicircular south door of the nave is the only remnant of the first Norman church built on this site, with its zig-zag or chevron moulding around the top, and the beak-head moulding on the jambs. The church was built at the beginning of the Decorated period, in or about the year 1300. The four arches that support the tower, the three-light pointed windows in both the north and south transepts, the square-headed windows of the chancel, the priests' door and the bold diagonal buttresses at the different angles of the building, are all reminiscent of that period.

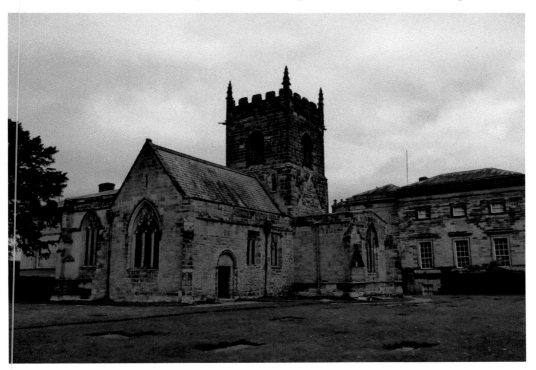

Church of All Saints, Kedleston.

The semicircular south door of the nave is a remnant of the first Norman church built on this site, having zig-zag or chevron moulding around the top, and the beak-head moulding on the jambs.

Priests' door, Kedleston.

The two-stage tower stands in the centre of the cruciform structure of All Saints' Church.

After being commissioned by the 4th Lord Scarsdale, the architect John Oldrid Scott carried out major restoration between 1884 and 1885. The work included building a new timber ceiling, raising the level of the roof line, laying a new floor, removing the box pews from the nave and inserting a new west window following the Decorated style of design.

There are in excess of thirty monuments to the Curzon family in the church, dating from the thirteenth to the twentieth century and including a number of freestanding tombs, wall monuments and floor tablets. A tomb chest dating from 1456 bearing effigies of Sir John Curzon and his wife can be seen in the south transept. The sides of the tomb are decorated with figures of their seventeen children. Another memorial – the earliest in the church – is also in the south transept and is dedicated to the memory of Thomas de Curzon, who died in 1245. The north transept also features a number of memorials to members of the Curzon family. There are memorials to Sir Nathaniel Curzon, 2nd Baronet and his wife, Sarah, and Sir Nathaniel Curzon, 4th Baronet and his family.

When Mary Victoria Curzon, 1st Lady Curzon of Kedleston, died prematurely on 18 July 1906 at the age of thirty-six, the grief-stricken Lord Curzon had a memorial chapel built to the north of the nave in his late wife's honour. The Gothic chapel, constructed over a large family burial vault, was designed by George Frederick Bodley and completed in 1913. Lord Curzon then charged the sculptor Sir Edgar Bertram Mackennal to create a marble effigy for her tomb. Lord and Lady Kedleston are buried, side by side, in the freestanding tomb.

The floor at one end of the memorial chapel can be lowered by means of a hydraulic system, giving access to the burial vault below.

Among the more unusual features of the church are the thirteenth-century stone heads of Richard de Curzon and his wife, which are to be found recessed below two round oak covers in the floor of the chancel.

With the exception of the glass made by the Swiss stained-glass artist, Franz Fallenter, most of the stained-glass windows in the church date from the late nineteenth or early twentieth century and are the work of Frederick Charles Eden. One of the windows in the chancel has stained glass dating from the seventeenth century, although the glass itself was only moved into the church at the beginning of the twentieth century.

The circular font dates from the eighteenth century and the wooden pulpit is from the nineteenth century. The eagle-shaped brass lectern dates from 1886. The altar itself is Jacobean in style.

William Hill & Son of London built and installed the organ in 1899. The organ, located in the north transept, was later enlarged and rebuilt by the same company in 1910.

Location: **DE22 5JH**

BIBLIOGRAPHY

Andrews, William, *Bygone Derbyshire* (Simpkin, Marshall, Hamilton, Kent, & Co. Limited: London, 1892).

Andrews, William, *Curious Church Customs* (Simpkin, Marshall, Hamilton, Kent, & Co., Limited: London, 1895).

Arnold-Bemrose, H. H., *Derbyshire* (Cambridge University Press: London, 1910).

Bowles, C. E. B., *Journal of the Derbyshire Archaeological and Natural History Society* (Bemrose & Sons Ltd: London, 1906).

Bradbury, Edward, *In the Derbyshire Highlands* (Bemrose & Sons: London, 1881).

Bryan, Benjamin, *Matlock Manor and Parish* (Bemrose & Sons Ltd: London, 1903).

Cox, Revd J. Charles, *Memorials of Old Derbyshire* (Bemrose and Sons Limited: London, 1907).

Cox, Revd J. Charles, *Notes on the Churches of Derbyshire* (Bemrose and Sons Limited: London, 1875).

Cox, Revd J. Charles, *Three Centuries of Derbyshire Annals* (Bemrose and Sons Limited: London, 1890).

Pendleton, John, *A History of Derbyshire* (Elliot Stock: London, 1886).

Vaux, Revd J. Edward, *Church Folklore* (Griffith Farran & Co.: London, 1894).

Acknowledgements

I would wish to record my thanks to many people who have assisted me in collecting and collating information with regard to the historic churches recorded in this text. I would especially wish to record my thanks to Mr Gordon Hughes (Melbourne Parish), Mrs Katherine Marples (Egginton Parish), Mrs Elizabeth Harrison (Pentrich Parish), Mr David Pickworth (Kirk Hallam Parish), and Hon. David Legh and Revd Dr John Vickerstaff (Cubley Parish). I would also wish to thank my wife, Janet, for accompanying me when taking photographs of the various churches mentioned in the text, and my son, Jon, who read and made a number of useful corrections to the manuscript.

With reference to the detail sketches included in the text, all, without exception, have been taken from J. Charles Cox's nineteenth-century text *Notes on the Churches of Derbyshire*.

Finally, while I have tried to ensure that the information in the text is factually correct, any errors or inaccuracies are mine alone.

About the Author

David Paul was born and brought up in Liverpool. Before entering the teaching profession David served as an apprentice marine engineer with the Pacific Steam Navigation Company.

Since retiring, David has written a number of books on different aspects of the history of Derbyshire, Cheshire, Lancashire, Yorkshire, Shropshire and Liverpool.

Also by David Paul

Eyam: Plague Village
Anfield Voices
Historic Streets of Liverpool
Illustrated Tales of Cheshire
Illustrated Tales of Yorkshire
Illustrated Tales of Shropshire
Illustrated Tales of Lancashire
Illustrated Tales of Derbyshire
Speke to Me
Around Speke Through Time
Speke History Tour
Woolton Through Time
Woolton History Tour
Churches of Shropshire